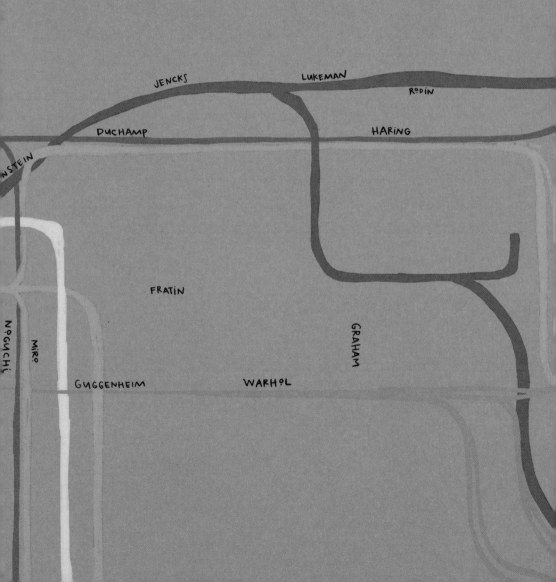

JENCKS

LUKEMAN

RODIN

DUCHAMP

HARING

NSTEIN

FRATIN

NOGUCHI

MIRO

GRAHAM

GUGGENHEIM

WARHOL

Art Hiding in New York

AN ILLUSTRATED GUIDE TO THE CITY'S SECRET MASTERPIECES

LORI ZIMMER

WITH ILLUSTRATIONS BY

MARIA KRASINSKI

RUNNING PRESS

PHILADELPHIA

Running Press
Hachette Book Group
1290 Avenue of the Americas, New York, NY 10104
www.runningpress.com
@Running_Press

Printed in China
First Edition: September 2020

Published by Running Press, an imprint of Perseus Books, LLC,
a subsidiary of Hachette Book Group, Inc. The Running Press name
and logo are a trademark of the Hachette Book Group.

The Hachette Speakers Bureau provides a wide range
of authors for speaking events. To find out more, go to
www.hachettespeakersbureau.com or call (866) 376-6591.

The publisher is not responsible for websites
(or their content) that are not owned by the publisher.

Print book cover and interior design by Amanda Richmond.

Library of Congress Control Number: 2020936670

ISBNs: 978-0-7624-7100-3 (hardcover), 978-0-7624-7101-0 (ebook)

RRD-S

10 9 8 7 6 5 4 3 2 1

This is for you, Dad.

CONTENTS

5.
Artists' Homes and Haunts

6.
Architectural Interventions

7.
What Once Was

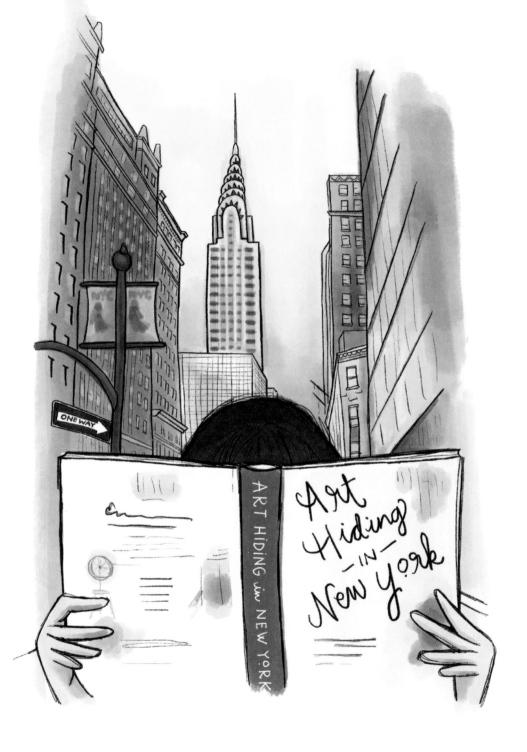

INTRODUCTION

For generations, artists have flocked to New York City looking for inspiration—to study with masters and to find their big break, their next gallery, and their next patron. The New York art world is constantly changing, but the marks and memories left by these seminal artists will always remain. *Art Hiding in New York* invites readers to follow in the footsteps of the great artists that have traversed Manhattan, stepping back in time to experience the narratives and remnants of the artistic giants of New York's past and present.

Sit beneath the mural where Maxfield Parrish painted a fart or at the hotel where resident Salvador Dalí stalked the halls with his pet ocelot; listen to a hidden sound installation in the thick of touristic Times Square; pass by the penthouse apartment where Jackson Pollock painted after long nights drinking at the Cedar Tavern; or experience a piece of Land Art that brings a snippet of sixteenth-century Manhattan to Noho.

Experience the lasting art history of New York in over one hundred narratives and illustrations. Explore the stories behind public artworks, the galleries that started it all, the privately owned works in the public view, the places to eat and drink surrounded by museum-quality paintings, and the sites where the artists lived, ate, and drank themselves. Whether you're a tourist or a local, open your eyes to our curated picks of the art of New York beyond the museums and galleries.

NOTE FROM THE AUTHOR

Ten years ago, I was unceremoniously fired from my Chelsea gallery job following the market crash of 2008. No one was hiring anywhere, especially in the art world. Refusing to leave my field—and with newfound time on my hands—I started a ritual of research to keep my artistic sanity. I'd spend the mornings applying for jobs, then the afternoons wandering around New York, taking note of sculptures, paintings, and architecture that I had been too busy to pay close attention to before. Like a true nerd, I jotted down my findings in a spreadsheet, then researched each place online or at the beautiful New York Public Library next to Bryant Park. As my findings grew, so did my obsession. I wanted to know where the artists I'd admired in university classes had lived, eaten dinner, and gathered together to discuss their work.

I never did find another job, but my project ended up becoming the beginning of the rest of my life. I turned my findings into a (now retired) blog called Art Nerd New York, which gained traction in the early 2010s and launched my writing and curating career. I'd always toyed with making my obsession into a book, but it was only after visiting my childhood friend Maria Krasinski in Tbilisi, Georgia, that I decided to truly go for it. Maria and I met when we were nine years old and had spent years traveling the world in search of art and architecture together, but I had no idea she was an artist until she showed me her drawings of Tbilisi one night in my Airbnb. I was so inspired at that moment that I decided I must write a book about art history in New York and she must illustrate it. I somehow convinced her to have total faith in this project and

to draw over one hundred illustrations with no promise of publication. We spent a year working on this book together, in cafés in Tbilisi and Paris, in the social club The Wing in New York, and in our hometown of Buffalo. It was completed during a dark year for me personally—while recovering physically from donating my left kidney to a friend and then emotionally from my dad's death two weeks later, working on and finishing this book became my light. This book is as much an extension of Maria as it is myself and an homage to our shared love of art and history. We are thrilled that our agent Lindsay Edgecombe from Levine Greenberg Rostan first believed in us and beyond excited that editor Shannon Connors Fabricant from Running Press felt the same way. We hope that you will sense the magic that we did while researching this book.

CHAPTER ONE

Surprising Spots

Under a grate in the middle of
Times Square, smack in the center
of the hell that is the Port Authority,
behind a wall of foliage in a private park,
or on the sidewalk under your feet,
masterworks of art are hidden in the
most surprising spots around this city.
Pull your head up from your phone
and look around—and sometimes up—
or you might just miss the treats that
artists have left for you to discover.

ALAN SONFIST
Time Landscape

HOUSTON & LAGUARDIA PLACE
NoHo

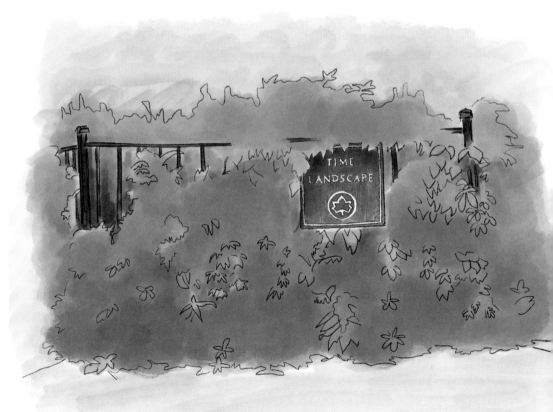

It is nearly impossible to imagine a Manhattan without the rising skyscrapers, tenements, and, more recently, glass towers that cram into every block of the grid. But a snippet of the Manhattan of the early sixteenth century is alive and well on the corner of LaGuardia Place and West Houston . . . at least 1,000 square feet of it. Nestled in a fenced-in plot along the sidewalk is Land Artist Alan Sonfist's 1965 masterpiece, *Time Landscape*.

The blooming foliage behind the fence looks like a typical city garden, a tiny portion of flora that New Yorkers consider wild space. But Sonfist's garden means so much more than a regular swath of green might, as it transposes a slice of precolonial Manhattan back to where it once was. The piece represents a rendition of the indigenous forest that would have flourished long before this corner saw the Lenapes, the Dutch, the Irish, industrialization, bohemian artists, designer shops, or the growing number of tourists that flock to New York each year.

The small patch of greenery is a lens into the past, set within an appropriately modern area of just 1,000 square feet. The forest of Ye Olde Manhattan features a small grove of beech trees—grown from saplings transplanted from Sonfist's favorite childhood park in the Bronx—and a woodland of red cedar, black cherry, and witch hazel above ground cover of mugwort, Virginia creeper, aster, pokeweed, and milkweed. The northern area of the piece is a mature woodland dominated by oaks, with scattered white ash and American elm trees. Among the numerous other species in this mini forest are sassafras, sweet gum, and tulip trees, arrowwood and dogwood shrubs, bindweed and catbrier vines, and violets. Experiencing the piece in spring is a feast for the senses to say the least.

Alan Sonfist, *Time Landscape*, 1965, corner of Houston and LaGuardia Place

ALEXANDER CALDER
Janey Waney)
GRAMERCY PARK

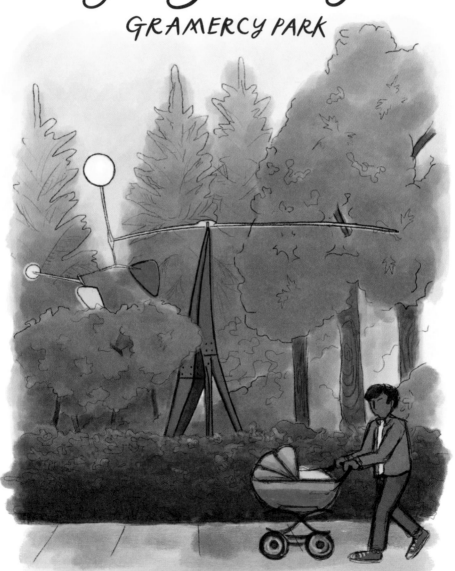

Manhattan's most famous private green space,

Gramercy Park, taunts passersby with tourist-free benches, lush foliage, and tranquil paths. In addition to urban zen, the perfectly manicured park boasts its very own Alexander Calder sculpture—meant for keyholders only. Called *Janey Waney*, the oversize mobile was commissioned in 1969 by—and thus named for—Warhol star "Baby Jane" Holzer. Holzer initially saw a small version of the sculpture at Calder's studio and asked for a larger-than-life version for the Smith Haven Mall on Long Island, which was developed by her then-husband. The mobile was originally placed in Gramercy Park on a one-year loan in 2011 by neighbor and president of the Calder Foundation Alexander S. C. Rower, but is now a permanent fixture here in between its European tours.

The piece is classic Calder. Its bright yellow, blue, and white pieces gently sway over an orange trunk-like base with the rustle of the breeze. But never mind that—this Calder is not meant for you! Since 1844, Gramercy Park has been closed to the public as a private urban oasis reserved for the residents of the expensive town houses that line its perimeter, accessible only by key.

Despite being closed off to the public, you can peer at *Janey Waney* through the thick foliage and flowers from the sidewalk just outside the historic wrought-iron fence, like an arty Peeping Tom. If you stand on your tippy-toes, you can almost feel like you're inside the park. (The neighbors love it when you do that.) Occasionally, the sculpture gets to break free from its gilded prison and see the world—it has traveled to Amsterdam and Paris, but always finds its way back.

Alexander Calder, *Janey Waney*, 1969, Gramercy Park

BERGDORF GOODMAN
Window Displays
754 FIFTH AVENUE at 58th STREET
MIDTOWN

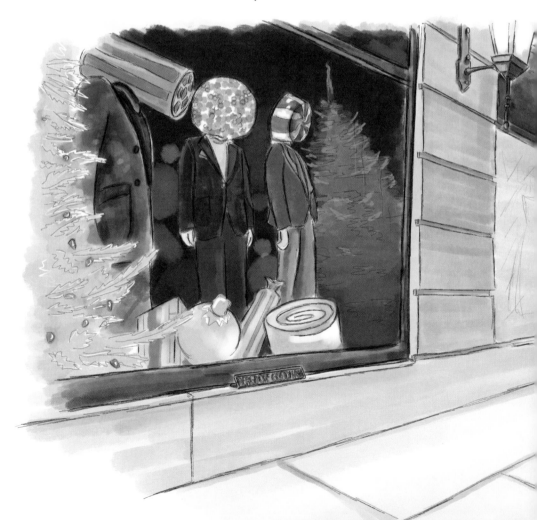

Ah, the beauty of window dressing! It's a surprising art form that can transform a walk down the street into a fantastical escape. The elegant Bergdorf Goodman is one of the only historic luxury department stores left in New York and, along with its top-tier goods, comes a breath of artistic air. The window displays here are by far the best in the city, if not the world, consistently weaving whimsical narratives with incredible vintage props, contemporary clothing, and the occasional borrowed master painting.

Bergdorf Goodman first opened in 1901 when tailor Herman Bergdorf took on apprentice Edwin Goodman. Their first shop was on 32nd Street, and they later moved to a large department store in 1914, on the site of what is now Rockefeller Center. The current location opened on the west side of Fifth Avenue in 1928, on the site of the razed Cornelius Vanderbilt mansion, which was then the largest private residence in New York.

People travel from all over the world to see the store's famous Christmas windows, but each holiday is equally impressive thanks to the vision of Senior Director David Hoey, who can take up to *six years* to plan and execute one theme! With the incredible quality (and number!) of props available to him, it is easy to believe that.

Visiting the windows late at night, long after the shopping droves have gone home, is truly a magical experience and an opportunity to appreciate every luxurious detail without interruption.

Bergdorf Goodman Windows, 754 Fifth Avenue at 58th Street

THE CARLTON ARMS ART HOTEL
160 EAST 25th STREET
GRAMERCY PARK

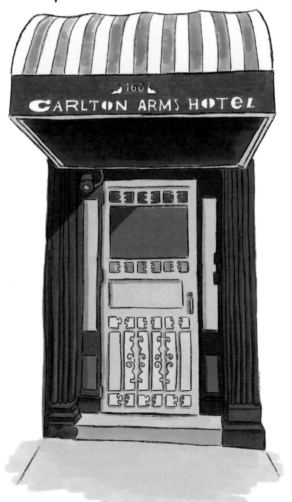

An unassuming door beneath a striped awning

on Baruch College's campus guards corridor upon corridor of original art. Art hotels have popped up across the globe, giving guests a private view of original works with their overnight stay. The Carlton Arms was one of the first places to fuse art with accommodation, and what it lacks in luxury it makes up for in creative spirit. The hotel was originally an SRO (single resident occupancy, basically a bedroom with a sink) full of all sorts of unsavory characters in the early 1980s. The hotel's manager at the time, Ed Ryan, decided to switch gears and make the hotel a happy place—rather than a home for the destitute. Ryan hired starving artists as front desk employees, and when the artists asked if they could paint murals throughout the five-story building, the art hotel idea was born. Since 1984, the Carlton Arms has literally changed from squalor to living art installation, thanks to the rotation of artists who have passed through its fifty-four rooms.

With art in every nook and cranny—down to the skeleton in the lobby—the hotel feels like a time machine to the old New York, complete with grit and a shared bathroom down the hall. It isn't shiny and new, but welcoming and clean, and captures the spirit of the bohemian, making visitors feel a part of something magical just by sleeping there.

The rates at the Carlton Arms are probably among the cheapest in New York, which is especially surprising since it is located only a few blocks from Gramercy Park. If you're not up for an overnight, you can ask the front desk for a walk through or attend one of their opening receptions, which happen a few times a year.

The Carlton Arms Art Hotel, 160 East 25th Street

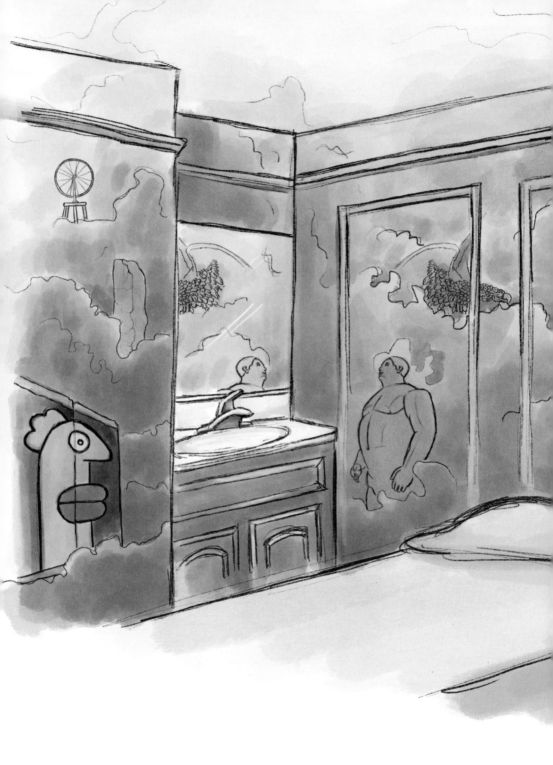

CHRISTOPHER JANNEY
Reach

34th STREET SUBWAY
(N & R LINE)
MIDTOWN WEST

Did you know you can summon a secret rain forest beneath Manhattan's concrete jungle with just a wave of your hand? Stretching along the platform of the 34th Street N/R subway lines below the always busy Herald Square are a row of ordinary looking green metal ducts. But these ducts have no utilitarian purpose. Instead, they are the key to an immersive experience begging to be touched: artist Christopher Janney's *Reach!* Since 1995, the inconspicuous installation has surprised straphangers awaiting the train by bringing forth a melody of nature and instrumental sounds that swirls through the subway grit.

Along the ducts, motion sensors inside eight "eyes" activate sounds that interrupt the regular commuter hustle and bustle—bursts of flutes, marimbas, animal calls, and environmental "sound images" which evoke places like the Everglades or the Amazon rain forest. Each eye enlivens a different sound, which together can be played like a giant urban instrument. The sounds are updated each year to create a new dialogue between the two platforms—but more importantly between commuters and their urban environment.

Christopher Janney, *Reach*, 1995, 34th Street Subway Station (N & R Line)

FERNANDO BOTERO
Adam & Eve

TIME WARNER CENTER
1° COLUMBUS CIRCLE
UPPER WEST SIDE

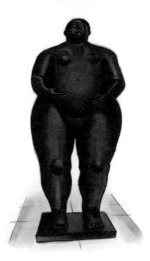

A curvaceous gentleman and buxom woman by

Fernando Botero are awaiting you in a shopping center at Columbus Circle! Trained as a matador and set designer, Botero has declared himself the "most Colombian of Colombian artists" and has flourished since he moved to Spain in the 1950s. Voluptuous bodies like these have become his calling card. His large bronzes are scattered in public spots around the globe, and in New York they greet shoppers at each of two escalators in the mall-like Time Warner Center.

The ample couple, *Adam & Eve*, tower over visitors, each standing twelve feet tall. Eve may be a little jealous, as public attention seems to focus on Adam, his private parts, and an insatiable desire to touch him! Visitors' fondling of Adam's nether region is not only a prime photo op; it has also left the patina gold and shiny! Feel free to experience it for yourself, but you may want to keep some hand sanitizer close by.

Fernando Botero, *Adam & Eve*, 1990, Time Warner Center, 10 Columbus Circle

FRANÇOISE SCHEIN

Subway Map Floating on a New York Sidewalk

110 GREENE STREET

SoHo

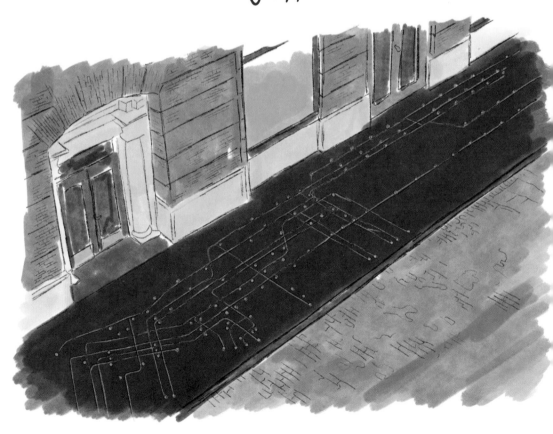

If you don't look down, you might miss a major
work of art beneath your feet on Greene Street! The brassy *Subway Map Floating on a New York Sidewalk* was installed by Francoise Schein in 1985 directly into the Soho sidewalk. The piece was commissioned by real estate developer Tony Goldman, who wanted to beautify the area in front of his building. Back then Soho was usually deserted at night, a hodgepodge of illegal lofts and industrial businesses, so Schein's piece really stood out in contrast with the near-empty streets around it.

The piece may be called a map, but don't try to find your way around the city with it! The ninety-foot bending subway "lines" stretch in a fantastical pattern, meant to flow like veins in the body, rather than accurately replicate the MTA system. The sculpture, viewed on the ground, is illuminated at night with LED lights embedded in the ceilings of adjacent buildings' basements, making it an entirely different sparkling experience at night. Although the Soho of today is dense with specialty stores and luxury apartments, the illuminated sculpture must have been a gorgeous sight in the dark and sparsely populated street of the 1980s.

Francoise Schein, *Subway Map Floating on a New York Sidewalk*, 1985, 110 Greene Street

GEORGE SEGAL
The Commuters

PORT AUTHORITY BUS TERMINAL
625 EIGHTH AVENUE
MIDTOWN WEST

In the 1980s, the Port Authority was more or less
a battle zone, rife with pimps, prostitutes, and drug dealers and
adjacent to a score of porn theaters. Despite its undesirable loca-
tion, two million commuters passed through its halls and gates
each day, working jobs in the city for a better life for their families.

In 1980, George Segal created *The Commuters* as a tribute to
these tireless souls. Segal's work is not so much a monument as it
is simply a snapshot in sculptural form. The three bronze figures,
painted in white patina, are displayed on the floor, rather than on
a pedestal as you would experience a rarified monument. His sub-
jects seem tired and rumpled, transfixed in a perpetual line, await-
ing a bus that will take them away back to their suburban homes—
or may never come at all.

Although New York is a much different place now, the figures
are still relatable, showing the all-too-familiar fatigue that com-
muters endured then and now. Their context has shifted, from an
act of escaping the danger of Manhattan to the modern reality of
not being able to afford to live in it.

George Segal, *The Commuters*, 1980, Port Authority Bus Terminal, 625
Eighth Avenue

KEITH HARING

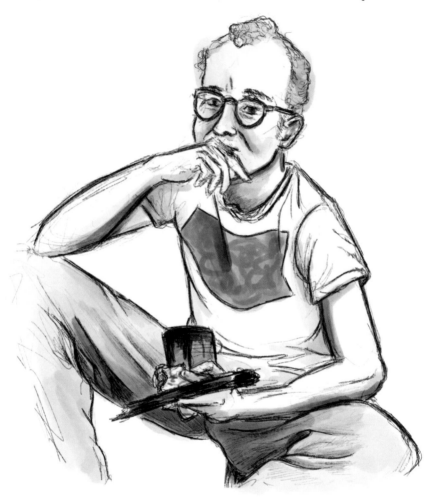

1958 - 1990

Keith Haring's life was short but bright (he died in 1990 at thirty-one). The artist left an everlasting impression on our culture, helping to elevate street art and graffiti into the world of fine art. Haring lived in New York for just twelve years, arriving in the summer of 1978 to study painting at the School of Visual Arts and remaining a resident until his death. In those twelve years he made his mark, both figuratively and literally, across the city. A few of those pieces remain, keeping Haring's spirit alive and new generations of art lovers intrigued.

KEITH HARING
Crack Is Wack

EAST 128th STREET at SECOND AVENUE
HARLEM

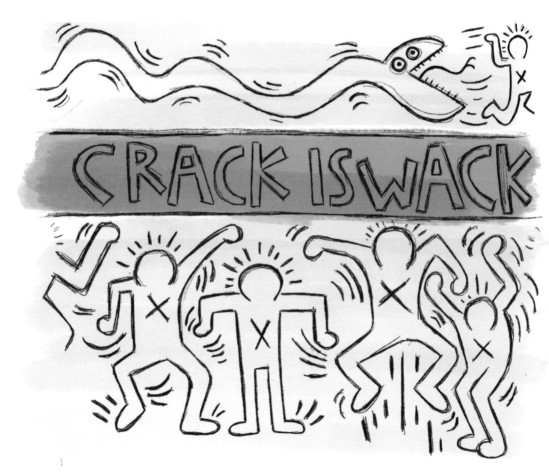

New York is constantly reinventing itself, but evidence of its past lives remains—both good and bad. The New York of the 1980s was a cutting-edge art scene, thriving with creativity, as much as it was a struggling city with a raging crack cocaine epidemic. In 1986 Keith Haring, always an art activist, transformed this handball court on 128th Street and Second Avenue into a warning after his studio assistant Benny became addicted to crack.

Haring often drove by the double-sided handball court, and one day he decided to paint an illegal mural to illustrate his frustration with the country's apparent indifference to addiction. In bold orange and Haring's signature enigmatic lines, the mural's message confronts motorists reentering the city after an upstate excursion, pleading for recognition of the drug that plagued many New Yorkers. Although we love to glamorize the "creativity and downtown scene" of the '80s, Haring's piece reminds us that the city was also a war zone, with crime and drugs running rampant around the near-rubble of the Lower East Side.

The *Crack is Wack* mural is one of the best surviving murals that Haring produced illegally, which is ironic considering the city's Department of Parks and Recreation was behind its restoration and protection. At the time, Haring was arrested for the graffiti after he finished it, but the mural's popularity and media attention got the charges against him dropped and his fine reduced to just $100.

Keith Haring, *Crack is Wack*, 1986, East 128th Street at Second Avenue

KEITH HARING
Carmine Street Pool

1 CLARKSON STREET
GREENWICH VILLAGE

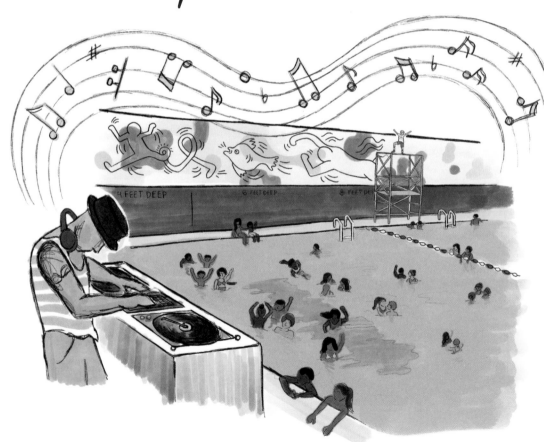

In the hot summer of 1987, things really started to sizzle at the Carmine Street Pool (now the Tony Dapolito Recreation Center) in the West Village. Imagine it: One of the most brutal days in August saw a typical scene of locals crowding the pool to seek refuge from the heat. But this day was one for the history books; while locals cooled off, Keith Haring painted a massive mural and DJ Junior Vasquez spun beats poolside.

The legendary event happened at the peak of Haring's career, but the artist continued to give back to the community until his death. Haring has said that the day painting the 170-foot mural "was one of the most incredible situations" he'd ever been in, and his frolicking dolphins, fish, and mer-creatures continue to enrapture swimmers and visitors today.

Keith Haring, Carmine Street Pool Mural, 1987, 1 Clarkson Street

KEITH HARING
Once Upon A Time

LGBT COMMUNITY CENTER
208 WEST 13th STREET
GREENWICH VILLAGE

One of Keith Haring's final public works in New York was perhaps one of his most personal. It portrayed the artist's celebration of sexual freedom, as well as an explicit and energetic commemoration of the twentieth anniversary of the Stonewall Riots. Painted in 1989, the black-and-white mural snakes around the bathroom of the Lesbian, Gay, Bisexual, and Transgender Community Center, its location chosen purposefully to tell the story of the sexual cruising of the gay community in the 1980s.

By 1989, HIV and AIDS had taken hold of the young artist and much of his community, turning Haring into an outspoken advocate for safe sex. Instead of condemning particular behaviors, this piece celebrates sex. Haring's signature bold-lined figures contort in erotic delight, with a multitude of body parts and bodily fluids spewing in the shapes of Haring's typical male figures. The massive piece reeks of orgasmic pleasure, but its title, *Once Upon a Time*, hints at a melancholy, perhaps looking back to the days of sexual "freedom" before the consequences of the AIDS epidemic devastated New York.

Although the space has been converted into a meeting room, the mural still holds its weight in sexual fantasy and has been lovingly restored by the center.

Keith Haring, *Once Upon a Time*, 1989, LGBT Community Center, 208 West 13th Street

KEITH HARING
The Life of Christ

CATHEDRAL of
ST. JOHN DIVINE
1047 AMSTERDAM AVENUE
UPPER WEST SIDE

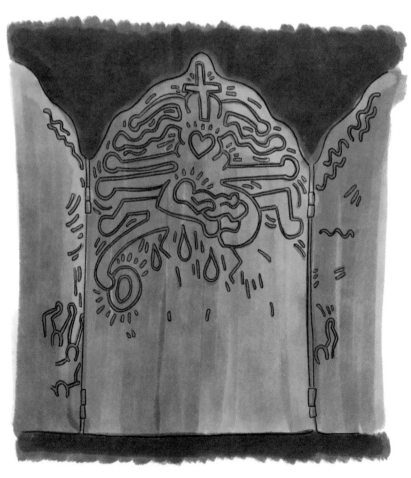

When Keith Haring finally succumbed to the

physical impact of HIV, he made one last work of art. In January of 1990, just one month before his death, Haring tackled an unlikely subject for him—religion. The bronze five by eight–foot triptych altarpiece is finished in white gold leaf and shows scenes from the life of Christ in classic Haring style. The piece weighs a hefty six hundred pounds and was produced as an edition of nine, with two artist's proofs (the rest of the series is dispersed in museums and churches around the globe). In the center of the triptych Haring's iconic baby figure becomes an infant Christ, held in a series of out-stretched arms. Instead of the usual serenity associated with images of the Birth of Christ, Haring's piece feels aggressive, with the wit-nesses to the birth seeming to move with flailing arms and clenched fists. Perhaps this feeling of unrest comes from the last moments of desperation Haring felt, as the artist realized that HIV/AIDS would get the better of him. In that way, the piece is very, very sad.

St. John Divine is a magnificent, suitable venue for Haring's last piece. It is the largest cathedral in the world (St. Peter's Basil-ica, at the Vatican, is bigger, but not a cathedral) and was built in the early 1900s. The church is also known for its interfaith tradition and acceptance, dedication to art (they hold modern exhibitions), and nonreligious community workshops (like an annual reading of Dante's *Inferno*)—all the makings of the perfect setting for Haring's last piece to live on.

Keith Haring, *The Life of Christ*, 1990, Cathedral of St. John Divine, 1047 Amsterdam Avenue

KEN HIRATSUKA
River & Nike Sculpture
25 BOND STREET
NOHO

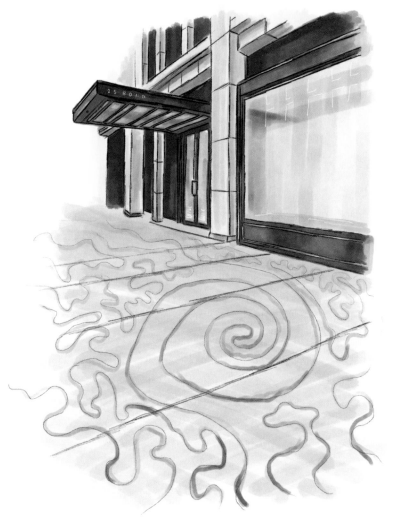

The swirls traced into the sidewalk in front of
25 Bond Street aren't the work of a gang of stick-wielding neigh-
borhood kids marking up the wet concrete in a construction zone.
The flowing grooves were incised into the gorgeous Chinese gran-
ite sidewalk in 2008 by Japanese sculptor Ken Hiratsuka, in "a single
continuous line carving chiseled by hand, guided by a fluid, oceanic
imagery" for his piece *River*. The artist has been carving continuous
lines around the world as a way to transcend the language of each
region and create what he calls "fossils of the moment" (how lovely
is that?).

This particular carving was sanctioned, commissioned by the
property owner. Hiratsuka has also spent years meticulously carv-
ing sidewalks secretly, and illegally. Down on the northwest corner
of Broadway and Prince you'll see another small carved line instal-
lation, which Hiratsuka worked on covertly over the course of two
years. Completed in 1984, the piece only took a total of five hours
to complete, but was chipped away little by little at night, in order
to not gain attention of the local police—now that is dedication! But
the work did gain the attention of the art world, and thus brings us
back to the expansive piece gifted to the public in front of 23 Bond.

The carved sidewalk installation leads into the building's
entryway, where Hiratsuka created a site-specific sculpture called
Nike. The average New Yorker may not be able to afford the luxury
of living at 25 Bond, but everyone can enjoy Hiratsuka's piece of
artistic luxury made for the building.

Ken Hiratsuka, *River* and *Nike*, 2008, 25 Bond Street

LEO VILLAREAL
Hive

6 TRAIN at
BLEECKER & LAFAYETTE STREETS
NoHo

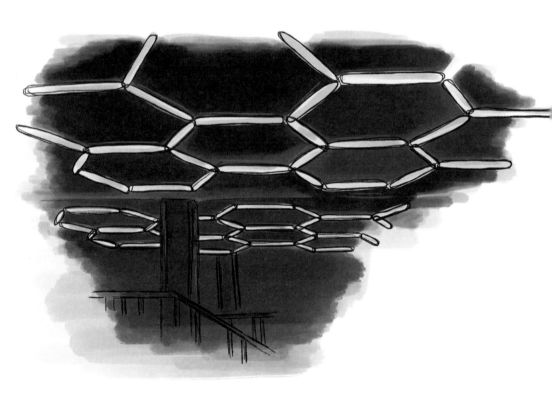

Navigating the city streets and subway can often feel like a real-life game of Frogger. And as commuters rise on the escalator to the platform for the 6 line at the Bleecker Street subway station, they are thrust into a glowing LED light installation of changing colors akin to an eight-bit video game. Light artist Leo Villareal's *Hive* is a multifaceted installation, meant to awe and delight with its varied meanings.

Sprawling across the ceiling of the station, a network of hexagonal shapes glows in an array of ever-changing colors. The varying hues of this honeycomb are set in a complex pattern, which Villareal based on the mathematical research of John Conway, the British mathematician most known for inventing an early cellular automaton video game called The Game of Life. As the human brain tries to make sense of the progressing patterns across the hive of LEDs, the commuters become worker bees, buzzing in and out of the network that is Manhattan.

Leo Villareal, *Hive (Bleecker Street)*, 2012, 6 Train at Bleecker and Lafayette

MAX NEUHAUS
Times Square

BROADWAY between 45th & 46th STREETS
TIMES SQUARE

To most New Yorkers, and many visitors, Times Square is an onslaught of sound, light, and chaos. In the middle of this dense commercial noise is a secret art installation many have probably never noticed. Wafting up from the subway grates of the pedestrian island on Broadway between 45th and 46th Streets is a rich harmonic sound that differs from the mélange of clashing Times Square noises. That distinctive tone is a sound sculpture installed in 1977 by Max Neuhaus. Aptly called *Times Square*, the piece is a low drone enveloping the small space it occupies, buzzing with a bass that separates itself from the rest of the area. Some take it for a broken train in the subway tunnel below, while others have mistaken it for a bomb about to detonate!

Despite being entirely out of context within the busy center, Neuhaus's piece is meant to blend in—with no sign or marker to be found anywhere—revealing itself only to those who are truly observant or in tune with the city sounds. Supported by the Dia Foundation, the installation became permanent in 2002, after its initial run from 1977 to 1992. It now operates twenty-four hours a day, seven days a week, emitting a ghostly presence amid the sensory overload that has defined the area.

The Times Square that inspired the work is long gone, but one can imagine the *oooommmm* sound of the piece experienced during the shady era of 1977 had a very different context than it does in today's Disney World version. Everyone should experience this installation in its two entirely different forms. First, watch tourists interact and react to the unexpected sounds during rush hour. The second form is more magical, long after midnight when Times Square becomes eerily vacant and the overpowering lights of the screens seem to be for no one. Then the drone becomes not just a sound, but a feeling—one that may have been the same for those standing on these grates in 1977.

Max Neuhaus, *Times Square*, 1977, Broadway between 45th and 46th Streets

ROy LiCHTENSTEIN
Times Square Mural

42nd STREET MTA STATION
TIMES SQUARE

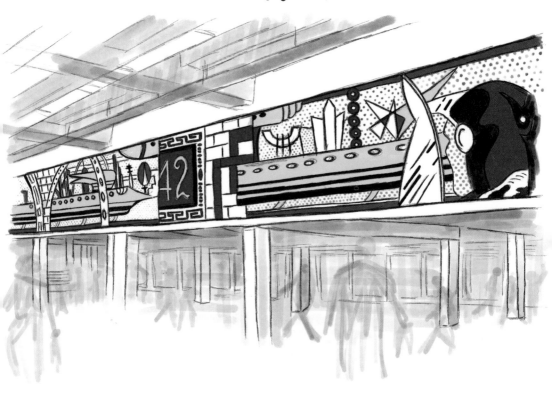

There is nothing like enjoying modern art masterpieces while running for the train below ground! The late, great, seminal Pop artist Roy Lichtenstein paid homage to the daily mind-numbing New York commute—from past to future—in this epic permanent piece in the constantly mobbed Times Square metro station.

Stretching fifty-three feet across and six feet high, Lichtenstein's classic Ben-Day dots flank images pulled from Buck Rogers comic strips, a bullet-shaped commuter spaceship hovering past swirly skyscrapers, and a throwback to the building of the subway in 1904, represented by his own Beaux-Arts rendition of the 42nd Street sign. The bold colors and graphic shapes in the mural echo the insanity of rush hour commuters below . . . minus the pushing and shoving. Lichtenstein made *Times Square Mural* in 1994 just a few years before his death, but the MTA didn't install the piece until 2002.

Roy Lichtenstein, *Times Square Mural*, 1994, 42nd Street MTA Station

TOM OTTERNESS
Life Underground

EIGHTH AVENUE L TRAIN STATION
CHELSEA

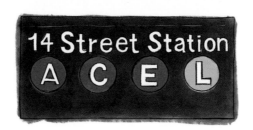

A beheaded woman, a man with a telephone in
place of his head, and a pair of giant feet all patiently wait for the
subway at the Eighth Avenue Station at 14th Street. (No, this isn't
the beginning of a joke!) In rounded, polished bronze, these are
only a part of a group called *Life Underground*, made specifically for
the MTA by artist Tom Otterness.

Otterness was commissioned in 1998 to create twenty-five
whimsical bronzes to live permanently on the subway platforms of
the L and ACE lines at this station. But the artist was so entranced
that he didn't stop when the project was fulfilled! Otterness kept
on casting characters on his own dime when the commission ran
out until he reached one hundred separate sculptures. He deliv-
ered all one hundred to the MTA, and they were installed by the
winter of 2000.

But cutesy cartoons were not always in Otterness's body of work.
The artist started his career with a controversial film called *Shot Dog
Film* which was shown on loop at a theater in Times Square in 1978,
and which inspired a sculptural reaction thirty-six years later. Two
artists, Andrew Tider and Lisa Barnstone, gave *Shot Dog Film* the
Life Underground treatment in 2014, installing a couple more rogue
sculptures of an Otterness-looking bronze shooting a dog amid his
actual work in the Eighth Avenue Station. They were later removed
by the MTA.

Tom Otterness, *Life Underground*, 1998–2000, Eighth Avenue at 14th Street,
ACE and L Train Station

WALTER DE MARIA
Broken Kilometer
393 WEST BROADWAY
SOHO

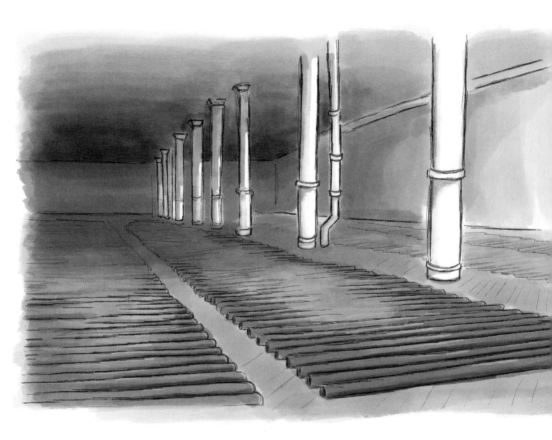

Tucked in the thriving shopping district of Soho

are two of the late Walter De Maria's massive installations, both of which call coveted Soho addresses their permanent homes. Supported by the Dia Foundation, the two experiences are within a few blocks of each other, occupying large, loftlike spaces the area was once known for. By sheer real estate alone, *Broken Kilometer* and *Earth Room* rank as some of the most expensive art installations in New York City.

Broken Kilometer resides on the street level of number 393, in between the fancy designer shops of West Broadway and reachable by a corridor leading to a large open room with Corinthian columns. Spanning the entire length of the cavernous space are five hundred shiny brass rods, perfectly lined up in five rows. Each rod is two inches in diameter and two meters in length, spaced apart in increments that increase by five millimeters, so that they appear equidistant from one another. The rods set end to end form one kilometer and are a companion to De Maria's *Vertical Earth Kilometer*, a one-kilometer brass rod placed into the earth in Kassel, Germany.

Broken Kilometer has been on view free to the public in this Soho space consistently since 1979.

Walter De Maria, *Broken Kilometer*, 1979, 393 West Broadway,

WALTER DE MARIA
Earth Room
141 WOOSTER STREET
SOHO

A few blocks and a flight of stairs away on Wooster Street is an entirely dirtier De Maria experience—250 cubic yards of it to be exact. *Earth Room* is just that, a Soho loft filled with 280,000 pounds of dark soil, piled to just past waist height. It doesn't do anything. You can't walk into it. You can only view it from one vantage point, unless you lean in over the clear plastic barrier.

But the piece's simplicity is powerful, as well as tranquil. Spread across 3,600 square feet of delectable real estate, *Earth Room* seems to swallow up the intensity of the city outside—in fact the dirt absorbs most of the city noise from Houston Street. Aside from the serenity of silence, the piece also plays on the power of the olfactory experience, as just one deep breath of the fresh-smelling soil can transport the visitor to a more bucolic setting. That fantastic smell has been the same since 1977. Each summer *Earth Room* is closed for cleaning, cultivating, and the occasional mushroom removal from the original soil that De Maria placed over forty years ago.

The existence of this interior earth sculpture, along with *Broken Kilometer*, is a silent victory over the mass consumerism of what Soho has become and can be enjoyed for free from autumn through spring.

Walter De Maria, *Earth Room*, 1977, 141 Wooster Street

CHAPTER TWO

DINE amongst the MASTERS

The perfect New York night out is
the right combination of a few things:
fine wine, fine company, and fine art.
Sit beneath a Maxfield Parrish while
sipping on an original Bloody Mary recipe
from 1932; take in world-famous jazz while
enveloped in a room of paintings by your
favorite childhood illustrator; or, for the
teetotalers, park your butt on a carved
wooden bench from the famous de' Medici
family while gazing at a painting from
the school of Caravaggio as you try
New York's original espresso.

Whatever your pleasure, dining
amid art will leave you feeling more
enriched than sneaking that flask
into your favorite museum . . .

BEMELMANS BAR
CAFÉ CARLYLE

THE CARLYLE
35 EAST 76th STREET
UPPER EAST SIDE

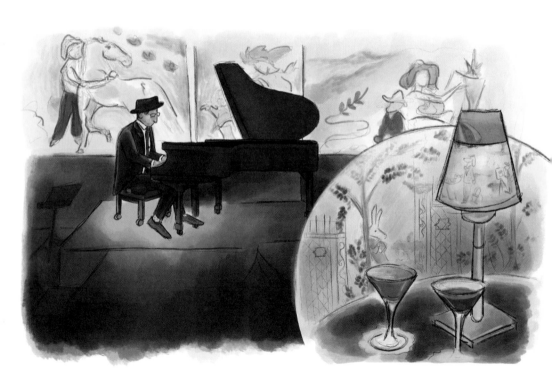

When Moses Ginsberg began building The Carlyle Hotel

lyle Hotel in the late 1920s, it was meant to be a luxurious Art Deco apartment hotel, a modern masterpiece with exquisite shops and restaurants for its residents on the ground floor. But when it was finally ready in 1930, New York's rich were recovering from the stock market crash, and so the hotel opened with a low profile and Ginsberg was forced to sell in 1932. Decades later, The Carlyle has achieved its original goal and become one of the most exclusive, and discreet, addresses in New York—as well as the subject of the 2018 documentary *Always at The Carlyle*. In addition to its lavish guest rooms, The Carlyle boasts two piano bars that bring guests smack into the middle of two unique art experiences.

The now famous Bemelmans Bar opened in 1947, when The Carlyle was on the upswing on its journey to glamour. Illustrator Ludwig Bemelmans was enjoying success with his children's book *Madeline*—which would soon become a well-loved series—when he was asked to create an all-encompassing mural for the new restaurant. Bemelmans graciously accepted and proposed that he and his family receive room and board at the hotel for a year and a half in lieu of payment. In 1946, Bemelmans began painting a whimsical mural dedicated to Central Park across the walls—and lampshades—of the bar that would soon bear his name. Rabbits, dogs, and elephants stroll in three-piece suits through the park, while nurses push baby carriages, men sell balloons, and a band plays in the famous band shell. Even Madeline is there, alongside her classmates who frolic through the grass. The wonderful mural is Bemelmans's only surviving artwork the public can view and was lovingly restored in 2007 using slices of Wonder Bread to soak up

years of nicotine buildup! The bar continues its tradition of live music every night.

In 1955, nearly a decade after Bemelmans Bar debuted, Café Carlyle opened as a reimagined 1930s-style Manhattan supper club cabaret—a tradition it continues today. Its walls are adorned with yet another wraparound mural, this time by French Hungarian illustrator and costume designer Marcel Vertès, whose music-themed mural was heavily influenced by paintings of the Moulin Rouge by Henri de Toulouse-Lautrec. In fact, Vertès won two Academy Awards for Best Art Direction and Best Costume Design for the 1952 *Moulin Rouge*. He also painted the murals at the nearby Waldorf Astoria's Peacock Alley Restaurant, which closed for renovations in 2017. Today, Café Carlyle is known as a premier venue, hosting performers like Alan Cumming, Tony Danza, and Judy Collins.

Both Bemelmans Bar and Café Carlyle are quintessential New York experiences, but they'll cost you. The cover charge at Bemelmans averages $25 a night, while Café Carlyle tickets can be upward of $249—not including drink or food minimums.

Bemelmans Bar and Café Carlyle, The Carlyle, 35 East 76th Street

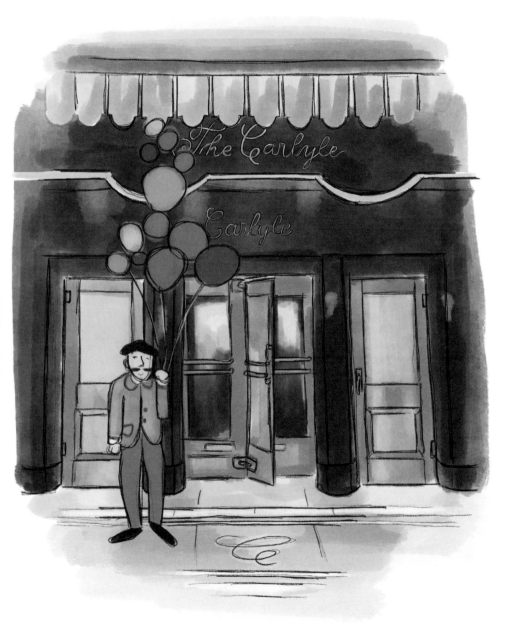

CAFFE REGGIO

119 MACDOUGAL STREET
GREENWICH VILLAGE

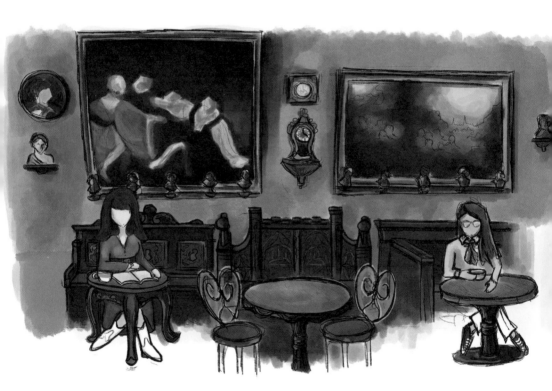

In a city of Starbucks on every corner, it is truly

a privilege to experience a cappuccino from the café where Italian espresso was first sipped by New Yorkers back in 1927. Historic coffee aside, Caffe Reggio in Greenwich Village is also a makeshift art museum, where customers have nonchalantly sipped lattes among Italian masterworks since it opened almost 100 years ago.

Caffe Reggio is a historical gem, a time capsule of a bygone era. Opened in 1927 by barber Dominick Parisi to offer up free cups of coffee to his waiting customers, the shop was soon outfitted with works of art—and a glorious espresso machine—from Parisi's native Italy. The artworks are not typical of a coffee shop: there are no local emerging artists hawking their wares here. Instead, the walls are adorned with a collection of historic pieces, some hundreds of years old, in a manner akin to a small museum or gallery.

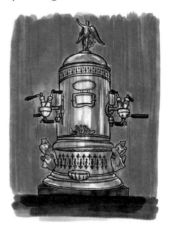

Throughout the café are over eighty original pieces, including a large painting by a student of Michelangelo Caravaggio, painted in the sixteenth century and restored by the Metropolitan Museum of Art in the early 1980s. Visitors can even sit on a relic while enjoying their coffee—a Renaissance-era wooden bench owned by the de' Medici family in the 1400s is pushed up to a table along with the vintage wrought-iron chairs that fill the dining room. Even the ornate espresso machine itself, adorned with gilded angels and horses, is a piece of art, made in 1900 for the world's fair and bought by the Parisis for a small fortune of $1,000. It still glimmers on display, but hasn't been used since the early 1990s.

Caffe Reggio, 119 MacDougal Street

THE GRAMERCY PARK HOTEL

2 LEXINGTON AVENUE
GRAMERCY PARK

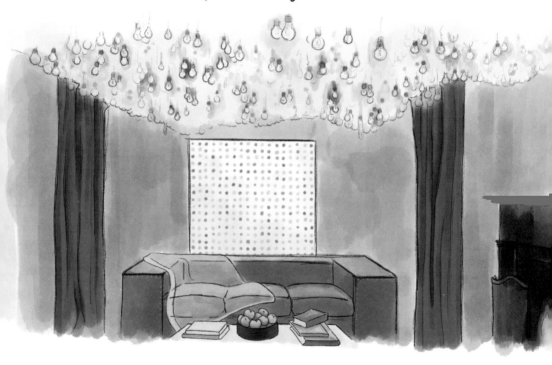

The Gramercy Park Hotel, situated just off New York's exclusive private park, is fancy. It is evident in every detail, in every facet of the hotel, that this place was created by an art lover—and that it was. Hotelier Ian Schrager, already known for his epic love of design, hired Julian Schnabel to oversee the decor. Schnabel designed all of the furniture in the hotel and bars and curated original photographs and artworks in the guest rooms.

The hotel's vast contemporary art collection is highlighted in the exclusive Rose Bar on the first floor and includes works by a lot of famous men—Jean-Michel Basquiat, Andy Warhol, Damien Hirst, Keith Haring, Cy Twombly, Richard Prince, George Condo, and David LaChapelle. The collection is regularly rotated to keep guests on their toes. The lone female artist included—Annika Newell —is known for her incredible light bulb installations. On the eighteenth floor, the Drawing Room is nearly swallowed up by clusters of hundreds of dangling light bulbs that make visitors feel they are part of Newell's piece.

The hotel was built in the late 1920s. Humphrey Bogart was married there; a young JFK lived there for a few months; Babe Ruth drank there; and Bob Marley, Bob Dylan, Madonna, and Blondie have all stayed there.

The Gramercy Park Hotel, 2 Lexington Avenue

HOTEL DES ARTISTES
THE LEOPARD

HOWARD CHANDLER CHRISTY
Fantasy Scenes with Naked Beauties

1 WEST 67th STREET
MIDTOWN WEST

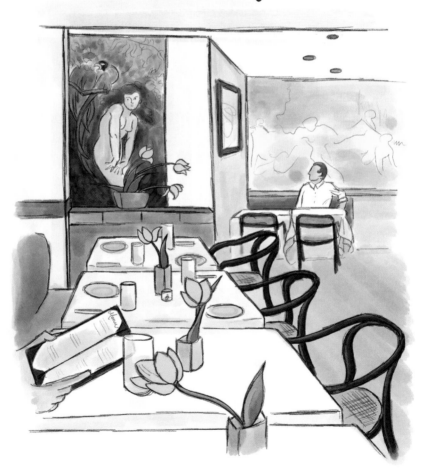

With double-height ceilings and massive windows
that drench each apartment with light, the Hotel des Artistes was
a place for artists of all genres to live, work, and flourish. Designed
in 1918 by George Mott Pollard, artists lived and worked in the lofty
studios and dined at the ground floor Café des Artistes (now The
Leopard des Artistes). When they were working, artists would take
meals in their kitchen-less studios upstairs—the restaurant would
regularly hoist meals directly to the lofts via dumbwaiters. Here,
masters of art, dance, performance, and the literary world con-
verged together through work and play. Marcel Duchamp was a
regular at the restaurant, as were residents George Balanchine,
Rudolph Valentino, Fanny Brice, and Norman Rockwell.

The restaurant remains a stunning glimpse of old New York.
Its walls are adorned with nine murals by former resident How-
ard Chandler Christy, who was known as the most popular portrait
painter of the Jazz Age. *Fantasy Scenes with Naked Beauties*, completed
upstairs in his studio at the Hotel des Artistes from 1928 to 1935,
shows nude nymphs frolicking in nature, painted in the artist's
Christy Girl style—a romantic successor to the Gibson Girl.

Hotel des Artistes, The Leopard, Howard Chandler Christy, *Fantasy Scenes
with Naked Beauties*, 1928–35, 1 West 67th Street

MURALS on 54

DEAN CORNWELL
Sir Walter Raleigh Murals

WARWICK HOTEL
63 WEST 54th STREET
MIDTOWN WEST

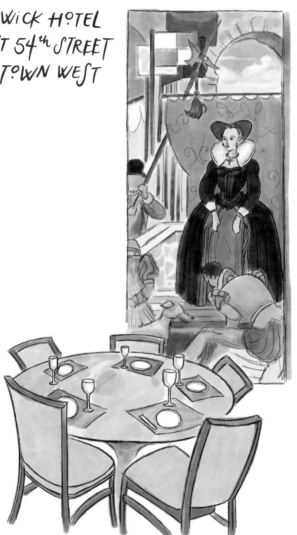

In 1926, publishing giant William Randolph Hearst opened the lavish Warwick Hotel to cater to the upper class—and his mistress, Hollywood actress Marion Davies. He commissioned illustrator and muralist Dean Cornwell to transform a room devoted to Sir Walter Raleigh into an artistic experience that honored the English writer and explorer's life. Cornwell covered the walls with scenes of Raleigh receiving his charter from Elizabeth I in 1584 and landing on the shores of Roanoke in Virginia.

Hearst promised to pay Cornwell handsomely, with a commission of $100,000 for the completed murals. But the shrewd businessman tried to make it difficult for the artist to collect. In protest, Cornwell decided to embellish the murals with some undesirable scenes, including a man peeing on the queen and a naked Native American mooning the viewer.

Once he was finally paid, Cornwell removed his painted protests, but a spiteful Hearst kept some of the murals covered for nearly forty years. In 2004, the works were fully restored and can be enjoyed over breakfast in the hotel's restaurant, Murals on 54.

Murals on 54, Dean Cornwell, *Sir Walter Raleigh Murals*, 1926, Warwick Hotel, 63 West 54th Street

NATIONAL ARTS CLUB

15 GRAMERCY PARK SOUTH
GRAMERCY PARK

In 1898, a group of art enthusiasts banded tog-
ether to form a club to foster art appreciation. *New York Times* art critic Charles de Kay established a board of directors, and The National Arts Club was born. The group amassed 1,200 members and founded a home base in 1906 at the Samuel J. Tilden House, a gorgeous town house right on Gramercy Park.

From its inception The National Arts Club welcomed both women and men as members, recognizing the importance of female artists in a time when women were not granted entry to many private clubs and salons. For over one hundred years, the club has hosted exhibitions, performances, lectures, and readings and has served as an elegant place for artists, collectors, and scholars to gather. Members can also access the coveted private Gramercy Park across the street.

Inside, the club is a living museum, with Tiffany-domed ceilings and an extensive collection of American paintings and sculpture that clutter every inch of its historic rooms. Members have included collector Henry Frick; sculptors Augustus Saint-Gaudens, Daniel Chester French, and Anna Hyatt Huntington; painter George Bellows; photographer Alfred Stieglitz; and even three US presidents—Theodore Roosevelt, Woodrow Wilson, and Dwight D. Eisenhower.

Nonmembers are often invited to enjoy the beautiful space for public openings and lectures. The mansion is simply breathtaking, packed wall to wall with incredible period furniture, busts, paintings, and sculptures. The National Arts Club is a gorgeous glimpse of early 1900s decadence, with relevant contemporary programming. Check ahead for times when the public are welcome.

The National Arts Club, 15 Gramercy Park South

ST. REGIS HOTEL
2 EAST 55th STREET
MIDTOWN

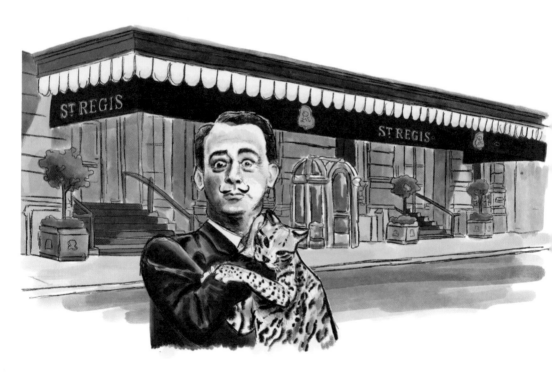

Gorgeously ornate and grand, the St. Regis Hotel
feels like a well-kept relic from another era. It is, in fact, drawn
from the time when the Astors and Rockefellers spilled their wealth
around New York with elaborate, decorative, boastful touches. John
Jacob Astor IV, one of the world's richest men until his untimely
death in 1912 aboard the ill-fated *Titanic* (yes, *that Titanic*), had the
St. Regis built in 1904, in the fashionable neighborhood near Cen-
tral Park, as a companion property to the Waldorf Astoria. Astor
packed the French Beaux-Arts hotel with opulence from floor to
ceiling—from over-the-top decorative moldings to trompe l'oeil
paintings, which have remained largely intact despite the build-
ing's having changed ownership several times over its century-plus
lifetime. Though the days of the Millionaire's Row are long gone,
the St. Regis has remained important to pop culture and storied
tales in art history, in addition to being one of the most extravagant
places to enjoy a $25 cocktail.

Since 1932, patrons of the hotel's King Cole Bar have been
able to enjoy the lush, lurid colors of an original Maxfield Parrish
painting, from which the bar derives its name. The famous *Old King
Cole* mural stretches across the back wall behind the bar, greeting
visitors with Parrish's signature saturated hues—and unlike in a
museum, those vibrant colors can be enjoyed with a stiff drink. The
massive mural may look innocent enough, but the story behind it
is a joke for the ages. Parrish, a Quaker, was hesitant to create a
commission for Astor's short-lived Knickerbocker Hotel, where
the piece was originally installed in 1906. Only after Astor offered

MAXFIELD PARRISH
Old King Cole

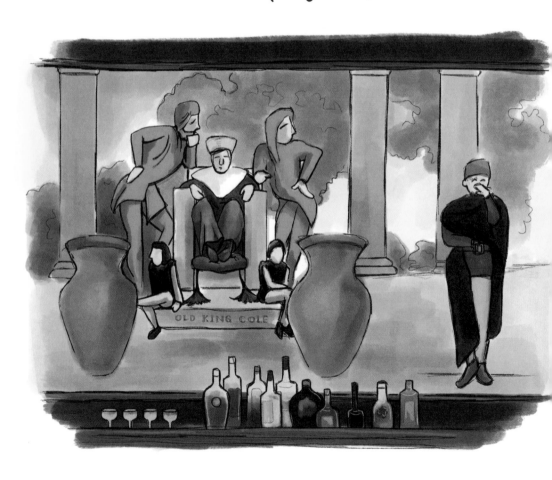

the kingly sum of $5,000 did Parrish finally relent and accept the offer—but not without a subtle and secretive act of defiance. In the center of the mural, which took residence at the St. Regis after Astor's other hotels closed, King Cole sits, flanked by two red-clad jesters. Look closely, and you'll see a smirk upon their faces, which is not just a figment of your martini-goggles. It seems Parrish has given Astor an eternal message, for beneath King Cole's robes, upon his throne, the king has cut the cheese, passed gas, broken wind. King Cole has farted and his entourage is laughing about it—and thus laughing at you for imbibing a fine cocktail beneath this mural. The joke's on Astor, the joke's on you, and Parrish has given us a laugh from beyond the grave.

It was also beneath this fabled mural that bartender Fernand Petiot introduced New York society to its first Bloody Mary in 1934. The bar later changed the drink's name to the more polished "Red Snapper," and Petiot's original recipe is still available on the menu.

Around the same time Petiot was shaking up those Bloody Marys, the St. Regis was accidentally becoming the center of the Surrealist movement in New York. The artistic style unfurled in suite 1610, where Salvador Dalí and his wife Gala took residence nearly every winter from 1934 until 1973. Under the haze of Dalí's enigmatic star power, the St. Regis fused old-world glamour and Surrealist modernity—whether through the presence of Dalí's pet ocelot Babou who lived at the hotel with him or the revolving door of art world impresarios who would come to visit the living legend in his room. Dalí used the St. Regis as his living quarters and his studio, creating masterpieces for both the Julien Levy Gallery and the Museum of Modern Art within its walls. It was in #1610 that Dalí obnoxiously manifested his Surrealist genius in real life—receiving

guests while sitting in a seven-foot chair lifted from his paintings, its spindly legs perched atop four turtles no less.

Dalí stalked the halls in garments made from dead bees, with Sarah Bernhardt's ornamented cane in hand and his mustache starched to the high heavens, signing autographs for his adoring fans—and even forcing some on innocent hotel guests. Dalí's unique extravagance suited perfectly a city like New York, and the lavishness of the St. Regis became the ideal catalyst for the relationship between artist and metropolis.

St. Regis Hotel, 2 East 55th Street

CHAPTER THREE

SECRETS of SCULPTURE

Day in and day out, we pass masterpieces of sculpture as we rush to work, the gym, a date, and back home again. So many of these go unnoticed in the fabric of our daily lives, but the works often hold secrets just waiting to be exposed. One sculpture that sits on a median in Lower Manhattan was originally a 7,100-pound piece of illegal street art! One of the most famous artists in history had a giant sculpture made for the city without ever setting foot in New York. The oldest sculpture in Central Park was heavily criticized and considered "gory" when it was installed over 150 years ago. And one sculpture was considered so risqué that for years it was on display not in New York City but . . . Wisconsin, of all places.

ALEXANDER CALDER
Saurien

590 MADISON AVENUE
at 57th STREET
MIDTOWN EAST

Perched underneath a cantilevered edge jutting out from the IBM Building on the corner of Madison and 57th Street, Alexander Calder's bright orange sculpture stretches its legs across the building's entrance, inviting visitors to walk around or under it—if they dare! The title *Saurien* (which is French, "Saurian" in English) describes a large reptile, and Calder's is most certainly a dinosaur, with its stegosaurus-like spikes emerging from an eighteen-foot back.

Although he is famous for his kinetic sculptural mobiles, Calder also made "stabiles," and *Saurien* is a fantastic example of such stoic works. These abstracted sculptures stand strongly, firmly rooted to the ground. Made in the artist's studio in Roxbury, Connecticut, in 1975, *Saurien* holds court on this busy corner, giving a silent roar to visitors to the IBM Building.

Alexander Calder, *Saurien*, 1975, 590 Madison Avenue at 57th Street

ARTURO Di MODICA
Charging Bull

26 BROADWAY
LOWER MANHATTAN

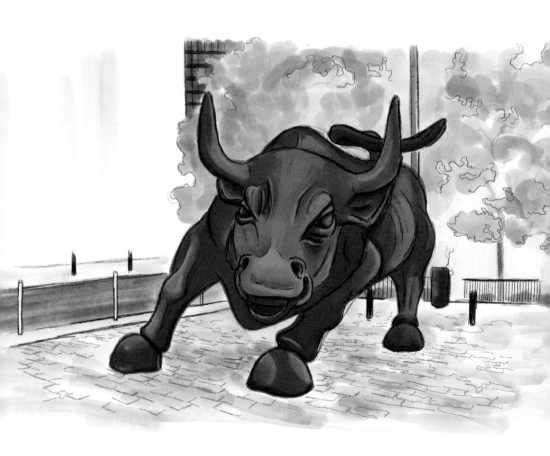

The massive bronze bull that sits near Bowling Green in Lower Manhattan is one of the most visited public sculptures in all of New York. What most people don't realize is that the sixteen-foot behemoth was originally an act of guerrilla street art.

After the 1987 stock market crash, artist Arturo Di Modica spent $360,000 to create, cast, and install the 7,100-pound sculpture he wanted to give to the citizens of New York as a symbol of "the strength and power of the American people." After casting the massive *Charging Bull* in Brooklyn in 1989, Di Modica trucked and placed the sculpture at the foot of a giant Christmas tree in Lower Manhattan near Wall Street—a holiday gift to the city.

At first, the police seized the sculpture and dragged it to an impound lot. But the public had already fallen in love with Di Modica's piece, and their protests led the city to install the oversize work at its current location in front of the Standard Oil Building. The sculpture is still technically impermanent, holding a temporary permit that has been in place since 1989, but it has become an enduring icon on Lower Manhattan.

Arturo Di Modica, *Charging Bull*, 1989, 26 Broadway

AUGUSTE RODIN
The Thinker

COLUMBIA UNIVERSITY
1150 AMSTERDAM AVENUE
UPPER WEST SIDE

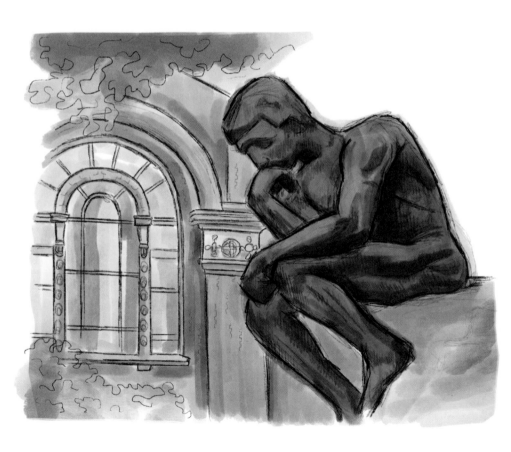

Rodin's *The Thinker* is one of the most recognizable statues in the world, and New York has its very own edition. The bronze sculpture in front of the Philosophy Hall at Columbia University was given to the university in 1930.

The sinuous piece was originally meant to portray Dante in contemplation before *The Gates of Hell*, another Rodin sculpture. But over the years it instead became a symbol of socialism—the figure evolved into a working-class hero when a copy was installed at the Panthéon in Paris during social upheavals in the early 1900s. And since then it's also become the symbol for intellectualism—as well as, perhaps just as famously, a dude sitting on a toilet, *deeeeeep* in thought.

Auguste Rodin, *The Thinker*, 1930, Columbia University, 1150 Amsterdam Avenue

AUGUSTUS LUKEMAN
Straus Park Monument
Audrey Munson
BROADWAY at 106th STREET
UPPER WEST SIDE

America's first supermodel eternally overlooks the reflecting pool in Straus Park on the Upper West Side. The forlorn bronze figure is in the image of turn-of-the-twentieth-century muse Audrey Munson. A favorite artists' model in the early 1900s, her stoic stances and sumptuous curves defy the ages in a dozen or more civic and private pieces in New York, including the giant bronze called *Civic Fame* atop the Manhattan Municipal Building in Lower Manhattan and the two female figures on the *Maine* Memorial at the southwestern entrance to Central Park. By 1913, she was considered the most beautiful woman in New York, and Alexander Stirling Calder alone cast her in 60 percent of the sculptures created for the Panama-Pacific International Exhibition.

In this tranquil park on 106th Street, Munson poses as a sea nymph looking over an expanse of water, sculpted by Augustus Lukeman in 1915. The sullen piece honors Isidor Straus and his wife Ida, who owned Macy's department store with Isidor's brother. In 1912, the Strauses were aboard the ill-fated RMS *Titanic*. The aging couple declined to board the lifeboats and gave their spaces up for young women and children. Ida refused to leave her husband's side, and they perished together in a poetic yet tragic death honored in this work.

Munson's death was not as poetic, but tragic nonetheless. After shooting to fame between 1910 and 1920, her star began to fall, as did her mental stability. She attempted an unsuccessful film career and was shunned after being the first woman to appear nude in a movie. Soon after, she was involved in several scandals while living in and out of boardinghouses with her mother. She wrote a nonsensical letter to the US State Department attempting to defame a rumored lover, marking her mental decline. In 1919 her landlord fell in love with her and murdered his wife so he would be free to

marry Munson. She denied having any involvement, but the trial deeply affected her career.

She never quite recovered, either personally or professionally. By 1931, at the age of forty, Munson's mother had her committed to a psychiatric center, where she lived out her days until the ripe old age of 104, mostly in chosen solitude.

Isidor and Ida Straus unknowingly share their memorial with a modern muse of art history, whose face was the epicenter of the art world as the *Titanic* sank.

Augustus Lukeman, *Straus Park Monument* (Audrey Munson), 1915, Broadway at 106th Street

CHRISTOPHE FRATIN
Eagles & Prey

CENTRAL PARK
near WEST 70th & RUMSEY PLAYFIELD

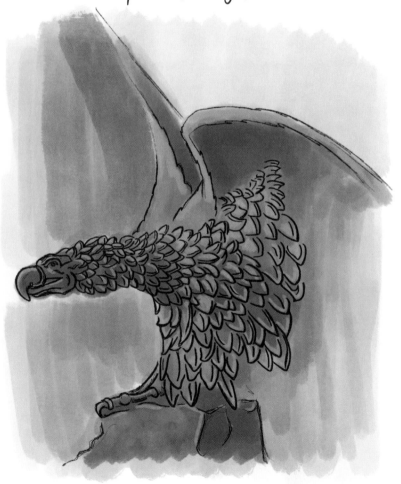

Since 1863, sculptural works have been integrated
with the carefully designed and landscaped vistas of Central Park—
thank you, Frederick Law Olmsted and Calvert Vaux. Most of the
works have been gifts to the public, offered by private donors or
organizations rather than purchased by the city.

The oldest piece in the park's collection is strikingly realistic,
and somewhat gory. Cast in Paris in 1850, *Eagles and Prey* shows two
eagles with wings spread in action, their talons ready to dig deep
into a very unfortunate goat. Although bronze, the piece shows
exquisite detail of the eagles' feathers, as well as the goat's fur,
looking more like taxidermy than sculpture.

In fact, the artist, Christophe Fratin, was the son of a taxider-
mist, an influence he brought to his sculptural work, looked down
on at a time when the only acceptable form for sculpture was the
human likeness. Despite this, manufacturing giant Gordon Web-
ster Burnham commissioned this work from Fratin, showing off
his wealth thirteen years later by giving the piece to the city. You
can find it adjacent to West 70th Street near Rumsey Playfield.

Christophe Fratin, *Eagles and Prey*, 1850, Central Park near West 70th Street
and Rumsey Playfield

FRITZ KOENIG
The Sphere
LIBERTY PARK
155 CEDAR STREET
LOWER MANHATTAN

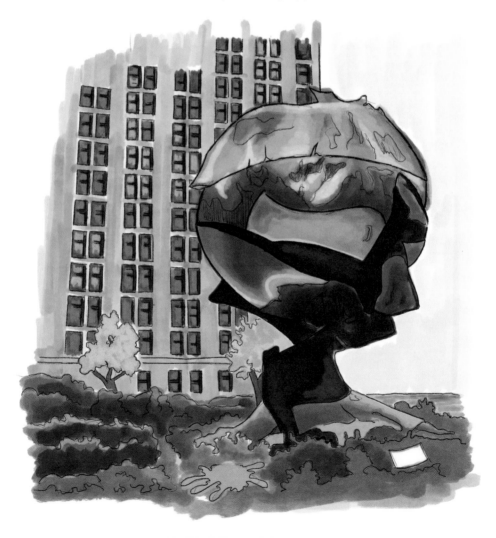

The Sphere, Fritz Koenig's massive bronze sculpture, stoically stood between the Twin Towers of the World Trade Center from 1973 until the September 11 attacks in 2001. Originally the twenty-five-foot-high sculpture was cast in fifty-two bronze segments that rotated once every twenty-four hours, set atop a ring of fountains by Minoru Yamasaki that mimicked the Grand Mosque of Mecca, Masjid al-Haram.

When the towers came down, the 45,000-pound sculpture was crushed and later found with an airplane seat lodged poetically in its surface. Structurally intact, the sculpture was moved into storage, with plans of restoration. But then art restorers began to see the damage as heroic battle wounds. Instead of being repaired, the sculpture was reinstalled, scars and all, serving as a symbol of the indestructible spirit of New York. Ironically, Koenig's initial intent for the sculpture was to symbolize world peace through global trade.

After spending fifteen years in Battery Park alongside an Eternal Flame, *The Sphere* was moved to a permanent home in Liberty Park next to the National September 11 Memorial. The work now lives close to its original location and has made a transformation from sculpture to monument.

Fritz Koenig, *The Sphere*, 1971, Liberty Park, 155 Cedar Street

GEORGE SEGAL
Gay Liberation Monument
53 CHRISTOPHER STREET
GREENWICH VILLAGE

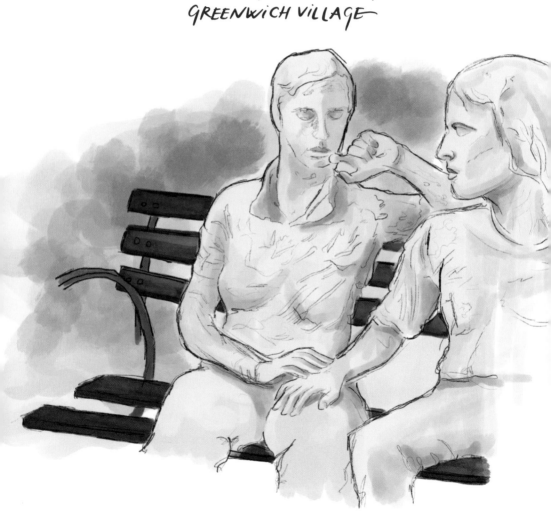

Across from the famed Stonewall Inn, in the gated Christopher Park, two male statues stand in a frozen intimate chat, while two female statues sit tenderly on a nearby bench. The sculptures—in the signature white-painted, cast style of George Segal—were commissioned in 1979 by the Mildred Andrews Fund to commemorate the ten-year anniversary of the Stonewall Riots, a series of violent uprisings that led to the gay liberation movement. The first Gay and Lesbian Pride Parade, which happened the next day, was a direct result of the riots and is known as the flash point for the gay rights movement.

The funder's only requirements were that the piece "had to be loving and caring, and show the affection that is the hallmark of gay people," and "had to have equal representation of men and women." Completed in 1980, it was somehow deemed too controversial for New York, so was installed in Madison, Wisconsin, from 1986 to 1991.

Segal's work was finally moved to New York in 1992, where it became the centerpiece for Christopher Park. It is the first piece of public art dedicated to LGBTQ rights. The little park is open to the public, and the Stonewall Inn is still open for business.

George Segal, *Gay Liberation Monument,* 1980, Christopher Park, 53 Christopher Street

ISAMU NOGUCHI
Red Cube

140 BROADWAY
LOWER MANHATTAN

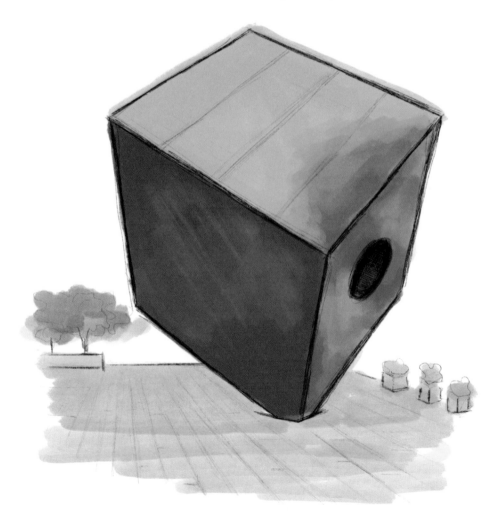

Isamu Noguchi's prolific career spanned from the 1920s until his death in 1988. Raised in Japan by his American mother after her breakup with Japanese poet Yone Noguchi, Noguchi was discouraged from being an artist until he began sculpture classes in New York and showed his true talent. Constantin Brancusi wooed the young artist to Paris to become one of his assistants, and under his tutelage Noguchi developed his incredible skill with stone. Brancusi's influence seeped into Noguchi's other work, leading the talented artist to expand from his stone sculpting to landscape, furniture, architecture, and set design.

Noguchi's first attempts to be accepted for the Public Works of Art Program proved unsuccessful, as one after another of his submissions were declined. *Red Cube*, however, was finally accepted and installed in 1968. Despite its name, the sculpture is a distorted box of diagonals, blazing red amid brown and black skyscrapers. With his experience in landscape design, Noguchi tied together art and architecture, which is evident when you look through the gray hole of *Red Cube*, which points directly to the building behind.

It is also said that the sculpture represents a die, a roll of chance, which takes on an appropriate context in NYC's Financial District.

Isamu Noguchi, *Red Cube*, 1968, 140 Broadway

J. SEWARD JOHNSON
Double Check
NW CORNER of
LIBERTY STREET & BROADWAY
LOWER MANHATTAN

A member of the family behind the Johnson & Johnson health and beauty empire, J. Seward Johnson tore free from the tear-free shampoo business to become an artist. His artwork is not highly conceptual, and for that he has been criticized—his entire oeuvre is chock-full of life-size bronze casts of actual people doing ordinary things. His sculpture of a businessman sitting with his briefcase was a representation of the quintessential 1980s Lower Manhattan: a typical suit double-checking his files with his oversize calculator and old-school tape recorder before going into a meeting.

This regular business guy accidentally became an impromptu memorial, when the sculpture was at the forefront of the September 11 attacks and survived. The lifelike bronze was found covered with debris from the towers, confusing first responders searching for survivors during the days after the attacks.

After briefly returning to Johnson's studio for safekeeping while the city cleaned up Lower Manhattan, *Double Check* returned to Zuccotti Park still bearing dents and scratches as a permanent reminder of that tragic day. The sculpture has since been moved a block away and now has an accompanying plaque.

J. Seward Johnson, *Double Check*, 1982, northwest corner Liberty Street and Broadway

JEAN DUBUFFET
Group of Four Trees

ONE CHASE MANHATTAN PLAZA
LOWER MANHATTAN

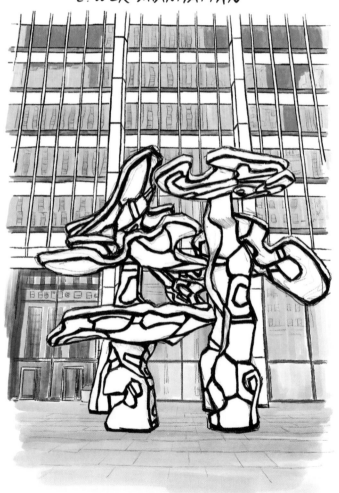

Many believe New York has an aura of magic, that it thrives with the electricity of myriad dreams from all over the spectrum. It is a place where aspiring artists, young chefs, hopeful real estate tycoons, actors looking for their breaks, and financiers striving for their first million flock, all pursuing the chance of making it big and following their very different paths alongside each other. Among the fiscal powerhouses of the Financial District, the wolves of one building meet the mind of one artist, Jean Dubuffet, each day as they pass through his larger-than-life sculpture guarding the Chase Manhattan Plaza.

Framing the banking giant's front doors, the black-and-white sculpture swirls in large, loopy strokes into a canopy of trees pulled from a coloring book. The lines of Dubuffet's *Group of Four Trees* leap off an imaginary picture plane, soar several stories high, and curve to form a three-dimensional rendering of a thick forest, with chunky black lines just begging to be colored in.

The sculpture was unveiled in 1972 and has invited the public to play beneath its boughs ever since.

Jean Dubuffet, *Group of Four Trees*, 1969–72, One Chase Manhattan Plaza

JEFF KOONS
Balloon Flower (Red)

7 WORLD TRADE CENTER LOWER MANHATTAN

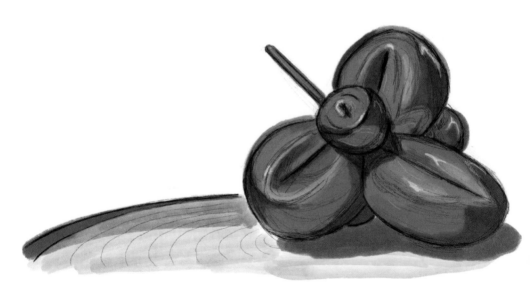

In the shadow of One World Trade Center, an oversize bright red balloon sparkles in the center of a fountain. *Balloon Flower (Red)* is from star artist Jeff Koons's Celebration series, in which the artist and his team beautifully transformed rigid high-chromium stainless steel into the supple and sensuous surfaces of tied, air-filled balloons.

The nine-foot sculpture is folded into six petals, placed on its face with a "stem"—presumably the balloon end—extending at a forty-five-degree angle toward the sky. The shiny surfaces are meant to reflect the viewer, but also the soaring skyscrapers behind them. Aside from being a relief from the heat in the summer—all are welcome to dip their toes in the shallow water—Koons says his sculpture doubles as an homage to 9/11 survivors.

Jeff Koons, *Balloon Flower (Red)*, 1995–2000, 7 World Trade Center, 250 Greenwich Street

JIM DINE
Looking Toward the Avenue

1301 SIXTH AVENUE
MIDTOWN WEST

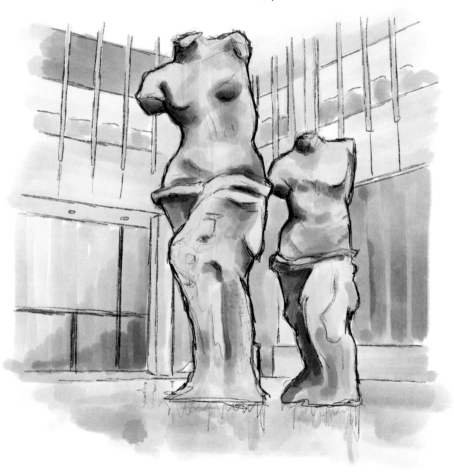

Long associated with the dawn of the Pop art movement, artist Jim Dine's New York public art presence has a more classical flavor. Within the canyon of steel architecture that edges along Sixth Avenue emerges a familiar sight in triplicate: Alexandros of Antioch's Venus de Milo.

Standing at fourteen, eighteen, and twenty-three feet high, Dine's Aphrodites are clad in oxidized patina and rendered with every groove, scratch, and marking of the original. Unlike the Greek source, however, the Venus de Milos of Midtown are not just missing their arms—they are also without their heads.

To Dine, leaving off their noggins creates a blank canvas on which he can project a range of emotions, separating the pieces from the context of their classical counterparts.

Jim Dine, *Looking Toward the Avenue*, 1989, 1301 Sixth Avenue

JOAN MIRÓ
Moonbird

14-40 WEST 58th STREET
MIDTOWN WEST

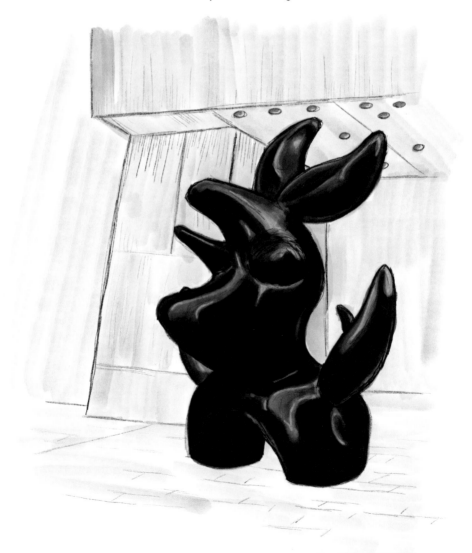

Before Joan Miró's fourteen-foot *Moonbird* sat in front of the north side of the Solow Building, an Alexander Calder teetered over pedestrians walking down 58th Street. One day, a strong gust of wind tragically toppled the sculpture. Since the twelve-foot Calder could've turned into death-by-art for passersby, the developer decided a more stable piece would avoid an impending death zone.

Solow was already a Miró fan and had a six-foot copy of *Moonbird* in his personal collection. When he found out there was a larger bronze available, he snapped it up for the rest of New York to enjoy. The curvy sculpture is reminiscent of ancient fertility goddesses, a creature that feels part animal, part human, and part fantasy. Named for its lunar-shaped face, the original was hand sculpted without preparatory drawings, in a style that is a mesh of Miró's interest in both Surrealism and ancient art.

It sits on a great spot: next to the beautiful windows at Bergdorf Goodman and across from the gorgeous old glamour of the Plaza Hotel.

Joan Miró, *Moonbird*, 1966, 14-40 West 58th Street

JOSEPH BEUYS
7,000 Oaks

22nd STREET between
TENTH & ELEVENTH AVENUES
CHELSEA

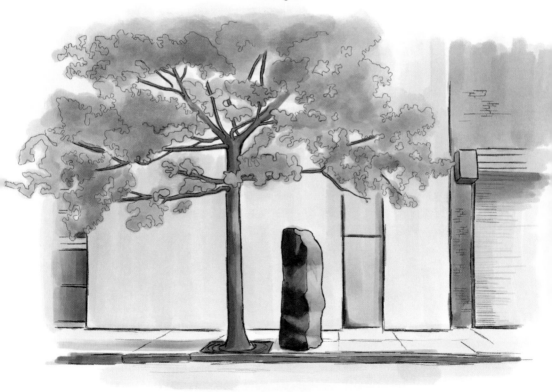

The trees lining 22nd Street in the Chelsea gallery
district won't just shade you as you trek from gallery to gallery—
they're also part of an art installation! Positioned between Tenth
and Eleventh Avenues, the thirty-seven trees are each paired with
a corresponding basalt marker, an extension of the seminal artist
Joseph Beuys's *7,000 Oaks* project that began at Documenta 7 in Kas-
sel, Germany in 1982.

Possibly the most important German artist of the postwar
period, Beuys was a sculptor, performance artist, installation artist,
graphic artist, and art theorist. He was known for installations using
bolts of gray felt and his performance living in a Soho gallery space
with a coyote for three days (*I Like America and America Likes Me*).

Beuys was also a social innovator. The original *7,000 Oaks* in
Kassel was created as a "social sculpture"; he believed revolution-
ary change was possible through universal human creativity. He
also believed that the inclusion of living trees in his art would cata-
lyze urban renewal around the world.

The Dia Foundation extended the Kassel project to 22nd Street
in New York City beginning in 1988 and reaching completion in
1996. In 1988, five trees with corresponding stones were installed.
Eight years later, twenty-five more trees were planted, including
a gingko, linden, Bradford pear, sycamore, pin oak, red oak, elm,
and honey locust, placed alongside twenty-five new basalt mark-
ers. Seven existing trees were given basalt partners, totaling thirty-
seven pairings in all. Beuys's installation is a permanent accompa-
niment to the bustling Chelsea arts district.

Joseph Beuys, 7,000 *Oaks*, 1988–96, 22nd Street between Tenth and
Eleventh Avenues

KARL BITTER & THOMAS HASTINGS

Pulitzer Fountain

FIFTH AVENUE & 59th STREET
CENTRAL PARK

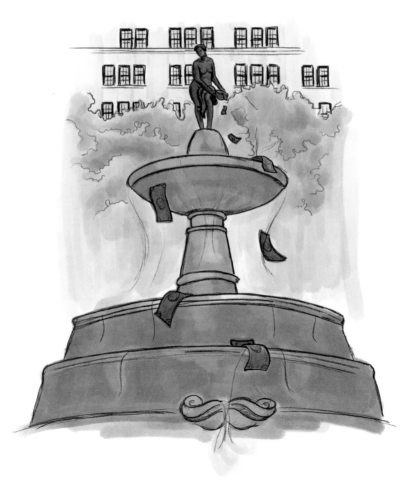

In the ultimate postmortem vanity plate to him-
self, Joseph Pulitzer left $50,000 in his will for the Pulitzer Fountain
to be erected in Grand Army Plaza at the southeastern tip of Cen-
tral Park. His instructions were to create "a fountain like those in
the Place de la Concorde in Paris." A design competition awarded
Karl Bitter and Thomas Hastings the honor, and their work was
erected in 1916. Bitter wanted the plaza to be symmetrical, so the
golden Sherman Monument was moved sixteen feet west to where
it now stands.

True to Pulitzer's empire of wealth, the bronze centerpiece is
of Pomona, Roman goddess of abundance. She pours water out of a
bowl into the pools below and is flanked by ram's heads with horns
of plenty to further emphasize Pulitzer's posthumous message of
wealth and material comforts. It fittingly sits in front of the present-
day Plaza Hotel and across from Central Park.

Karl Bitter and Thomas Hastings, *Pulitzer Fountain*, 1915–16, Fifth Avenue and
59th Street

LOUISE BOURGEOIS
Eyes

BATTERY PARK
LOWER MANHATTAN

Corneas or areolas? Louise Bourgeois's *Eyes* in Battery Park is just like the artist was—cleverly deceiving. Her two-piece sculpture faces the Hudson River with two polished orbitals looking out over New Jersey. But the work's protruding pupils hark back to Bourgeois's sensuous sculptures relating to the female body, begging the question if the artist intended more than meets the eye?

Louise Bourgeois, *Eyes*, 1995, Battery Park

LOUISE NEVELSON
Shadows & Flags
MAIDEN LANE & WILLIAM STREET
LOWER MANHATTAN

As glamorous as she was witty, Louise Nevelson fought the misogyny of the New York art world with a tenacious fervor that has left a legacy for artists, sculpture, and feminists alike. Known for her eclectic style, cunning humor, and incredible determination, she shocked and awed the art world with masculine sculptures that anchored her in art history. The Russian-born Nevelson lived life by her own rules, leaving an oppressive husband who wanted her to stay at home to pursue art studies, first in Paris, and then in New York under greats like Kenneth Hayes Miller, Chaim Gross, and Hans Hofmann. Shirking the traditional married life came with its own costs, including leaving her son in the care of his father or her parents for long periods of time, as well as her own subsequent poverty—the result of refusing alimony after her divorce. But the ardent Nevelson was determined to live a liberated life as an artist in New York City at any stake.

She caused drama with Frida Kahlo by falling into bed with Kahlo's husband Diego Rivera after assisting him on his ill-fated mural at Rockefeller Center. And Nevelson's sixty years in New York were not always filled with success; during the Depression she and her son would spend days wandering the streets to collect firewood to keep warm, which later became the inspiration for her signature monochromatic sculptures. But high and low, she loved the city—and the city loved her. Both her work and her enigmatic look of thick false eyelashes, big jewelry, and fur coats became fixtures in the New York art scene from the 1930s until her death in 1988.

Translated into Cor-Ten steel, her sculptures are forever honored in her beloved New York, arranged to echo the surrounding skyscrapers in Lower Manhattan. The plaza, installed in 1978, was the first public space in the city to be named after an artist, an accidental feminist statement perfectly honoring the woman who once said "I *am* a woman's liberation."

Louise Nevelson, *Shadows and Flags*, 1977, Maiden Lane and William Street

MARISOL

American Merchant Mariners Memorial

BATTERY PLACE
LOWER MANHATTAN

With the high tide, a bronze-sculpted mariner
drowns just out of reach from his fellow soldiers in the waters off
of Battery Park, a twice-daily reminder of the tragic United States
Merchant Mariner casualties of World War II. Three bronze figures
are seen on the corner of a sinking ship set on a stone breaker, one
extending his hand to a figure half-submerged in the water who
tries in vain to grab hold. As the day passes, the figure's head is sub-
merged, its patina tarnished with the rising and falling of the tide.

The emotional memorial pays tribute to over 20,000 Merchant
Mariners who were killed or lost at sea. French Venezuelan artist
Marisol Escobar (known simply as Marisol) was chosen to sculpt
the memorial after an extensive competition. Her piece, which
was dedicated in 1991, is based on an actual photograph taken by
the Nazi U-boat captain, capturing his victims after the Germans
attacked a United States Merchant Marine.

Marisol was largely known for her involvement in the Pop art
movement, as well as her roles in Andy Warhol films, and is con-
sidered an underappreciated Pop artist due to her "feminine" view
in art.

Marisol, *American Merchant Mariners Memorial*, 1991, Battery Place

MARK DI SUVERO
joie de Vivre
ZUCCOTTI PARK
LOWER MANHATTAN

To some, Mark di Suvero's *Joie de Vivre* is overwhelmed in dense Lower Manhattan. His work at Storm King, in upstate New York, is more striking with the juxtaposition of the bright steel against the lush rolling hills of the park a beautiful contrast. But in the cityscape, the seventy-foot red Cor-Ten sculpture gets lost among the ever-growing scaffolding of constant real estate development.

Surprisingly, the construction site comparison is not completely off base. Before di Suvero became an artist, he was a construction worker and involved in a serious elevator accident that left him a paraplegic. The traumatizing experience changed him for life, and even though he miraculously learned to walk again, the incident served as the inspiration for his life's work as a sculptor. That said, he was also the first sculptor to use a crane as a sculptor's tool.

The sculpture was moved from the Holland Tunnel Rotary to Zuccotti Park in 2006 and immortalized when Occupy Wall Street unfolded at its feet.

Mark di Suvero, *Joie de Vivre*, 1997, Zuccotti Park

PABLO PICASSO
Bust of Sylvette

UNIVERSITY VILLAGE
505 LAGUARDIA PLACE
NoHo

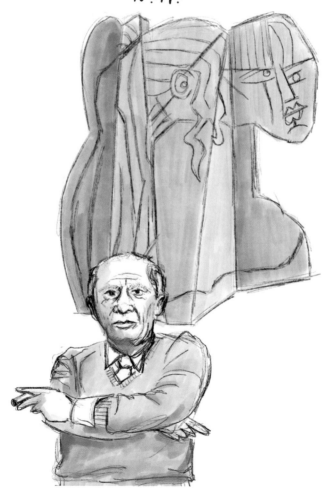

It's hard to believe that as one of the most famous

artists of all time, Pablo Picasso never set a foot in New York—or the United States for that matter. Picasso's influence was nevertheless felt heavily across the American art scene—a feat for a world before the internet. Thus, New York City's sole example of public art by the Spanish master was not actualized by Picasso himself, but erected by Norwegian concrete artist Carl Nesjar. Since 1967 the large-scale version of Picasso's *Bust of Sylvette*, has held court between I. M. Pei's glittering Silver Towers complex at University Village, at the time nodding toward the burgeoning art scene of Soho.

Upon designing Silver Towers, Pei envisioned a large-scale version of one of Picasso's folded-metal sculptures of Sylvette David to complete the project. Picasso himself gave his friend Nesjar permission to interpret the work in sixty tons of sandblasted concrete. But should this work—as a collaborative interpretation—be considered a "real" Picasso?

Ironically, the subject of the piece Sylvette—whom Picasso created a series of paintings and sculpture of around in 1954—has also been criticized by experts as not "feeling" like a true Picasso model. The young woman, a neighbor of Picasso's on the Côte d'Azur, was engaged to a young man—and unlike his other models, resisted Picasso's seduction. Critics argued that this lack of romantic entanglement made the series of Sylvette suffer, devoid of intimacy.

Regardless, the massive sculpture may read as a double-faux Picasso on paper but the concrete interpretation still reflects the master's sharp Cubist vision that influenced the world.

Pablo Picasso/Carl Nesjar, *Bust of Sylvette,* 1968, University Village, 505 La Guardia Place

PENELOPE JENCKS
Eleanor Roosevelt Memorial

RIVERSIDE PARK at 72nd STREET
UPPER WEST SIDE

One of history's most important human rights activists, Eleanor Roosevelt is honored eternally with a throwback to public art in the days of yore—a traditional, tasteful bronze. Casually leaning against a rock at the entrance to Riverside Park at 72nd Street, this *Eleanor* came to fruition at the hands of artist Penelope Jencks, after she rose to the top of four hundred other applicants who submitted their visions of the former first lady.

Jencks grew up in a household that regarded Eleanor Roosevelt highly and regularly quoted her, which is evident in the artist's interpretation of a wise, dignified woman. She studied hundreds of pictures of Eleanor before choosing a contemplative pose for the statue. The piece was dedicated in 1996 by another first lady and great thinker, Hillary Rodham Clinton.

Eleanor Roosevelt is the first American woman for whom a statue was commissioned for a city park. She sits atop a large chiseled boulder, pensing about something—given her history, most likely, world peace.

A tidbit of Eleanor's wisdom is imparted on the sidewalk in front of the large statue:

> *Where, after all, do universal human rights begin?*
> *In small places, close to home. Such are the places*
> *where every man, woman, and child seeks equal*
> *justice, equal opportunity, equal dignity.*

—ELEANOR ROOSEVELT, 1958

Penelope Jencks, *Eleanor Roosevelt Memorial*, 1996, Riverside Park, 72nd and Riverside Drive

ROBERT GRAHAM
Duke Ellington Memorial

FIFTH AVENUE at 110th STREET
HARLEM

Duke Ellington and his big band's jazz stylings
heated up Harlem's notorious whites-only speakeasy, The Cotton
Club, in the 1920s and became its official house band in 1927. His
incredible contributions to jazz and the Harlem Renaissance left
an unforgettable legacy not only to music, but also to the African
American community in Harlem and beyond.

Ellington is honored thirty-two blocks south of the club that
put him on the map with a massive sculpture that rises two sto-
ries tall. The brainchild of music enthusiast Bobby Short, the *Duke
Ellington Memorial* was dedicated in 1997 after being in the works for
eighteen years. Short had seen a bust of Louis Armstrong in Paris
and wanted to honor Ellington in the same way. He raised the funds
himself and commissioned sculptor Robert Graham to create a
piece that captures a scene of Ellington straight out of the 1920s.

Cast in bronze, Ellington stands next to a grand piano, about to
bow after a performance, on a stage held up by nine dancing muses.
The bronze looks toward the northeast corner of Central Park.

Robert Graham, *Duke Ellington Memorial*, 1997, Fifth Avenue at 110th Street

ROBERT INDIANA
LOVE

SIXTH AVENUE & 55th STREET
MIDTOWN WEST

Philadelphia's LOVE Park was made famous by Robert Indiana's *LOVE* sculpture, but it is not the only rendition of this iconic sculpture in existence. Before it came to life in three dimensions, the original image was designed for the Museum of Modern Art's holiday card in 1964.

The first realization in 3D was a colorless Cor-Ten steel sculpture made in 1970 and shown in New York. (That particular sculpture has been on display at the Indianapolis Museum of Art since 1975.) Now with many multicolored versions around the globe, a red one invites visitors to climb in and on the giant letters, just a block from the Museum of Modern Art.

Robert Indiana, *LOVE* sculpture, 1973, Sixth Avenue and 55th Street

THiERRY NOiR & KiDDY CiTNY

Berlin Wall

385 SOUTH END AVENUE LOWER MANHATTAN

The vibrant rock and roll scene ruled by David Bowie and Iggy Pop in West Berlin is what first lured French artist Thierry Noir from his home of Lyon to the divided German capital in 1982. Once settled into a squat facing the Berlin Wall in Mariannenplatz, Noir stared at the ominous divider of East and West for two years before he got the idea to demystify the oppressive symbol by using it as a canvas.

From 1984 until the fall of the wall five years later, Noir painted sections with his large, simplistic, colorful heads, which could be executed quickly under cover. His paintings inspired others to create murals of their own along the seventy-mile barricade that stretched between East and West Berlin. Noir's paintings made up almost a mile on their own.

Noir's work became synonymous with freedom, and after the wall was opened in 1989, several of his murals were relocated around the world to inspire hope. New York has several fragments of the Berlin Wall, with two major pieces from Noir. One portion in Midtown was part of an impromptu government sale in Berlin in 1990 and purchased by real estate company Tishmann Speyer's Jerry Speyer, who installed it on 53rd Street the same year. The other piece was given to Battery Park by the German Consulate in 2004, where it still sits at Kowsky Plaza.

Thierry Noir and Kiddy Citny, *Berlin Wall,* between 1984 and 1989, Kowsky Plaza, 385 South End Avenue

Remember the *Alamo*! Tony Rosenthal's Cor-Ten steel public sculptures dot Manhattan. Like many Minimalist sculptures of the late 1960s and early 1970s, their industrial design is sometimes camouflaged within the context of the architecture of the city. Rosenthal's *Alamo*, which is most commonly known as *The Astor Place Cube*, has become a central element of the East Village.

The cube, a local monument since 1967 with a brief removal for restoration, was originally supposed to inhabit Astor Place for just six months. Locals loved the piece so much they petitioned for it to stay, making Rosenthal's *Alamo* the first permanent contemporary outdoor sculpture installed in New York. Rotated onto its tip, the piece became a favored meeting place, where the Warhol crowd would gather before heading to St. Marks during its bohemian days. In the late 1970s and '80s the area became a punk haven, so punks would gather at the sculpture en route to the Continental for shows or to Trash and Vaudeville to shop. *Alamo* was also important to the skateboarding scene of the 1990s, when the plaza around the sculpture became an impromptu skate park.

Alamo has seen the intersection change drastically over the years, yet it continues to engage the public who sit under it, skate around it, and bond while spinning the 1,800-pound sculpture on its axis.

Tony Rosenthal, *Alamo*, 1967, Astor Place, Lafayette at 8th Street

CHAPTER FOUR

LOOK to the LOBBIES

Corporate lobbies are generally considered dreary places; the pristine points of entry where thousands of drones scan in and out of their longer and longer New York workdays. But for the rest of us, many of these stoic lobbies are impromptu venues for art, showcasing corporate collections that are often hidden from the public eye. Enjoying these masterworks does require a bit of stealth—my favorite thing to do is slowly walk through a lobby while faking a phone call with an imaginary employee of said building, whom I'm waiting to meet for lunch. (This pretend employee is always waiting for you at the restaurant, after you've had your fill of the artwork on display, of course.) If this ruse makes you nervous, fear not—there are plenty of pieces that can be enjoyed safely from the outside looking in.

BEN RUBIN & MARK HANSEN

Moveable Type

620 EIGHTH AVENUE
MIDTOWN WEST

The art collections of many of New York's corpo-
rations are well-guarded secrets, but some are actually accessible
for the public to enjoy. The *New York Times* has one such piece, a
lively, site-specific installation right in their Times Square lobby.
Created by tech wizards Ben Rubin and Mark Hansen, the work
Moveable Type culls headlines and quotes from the newspaper's
more than 150-year-old archive. These bits of text are then given a
second life sliding across the digital screens of the installation. Set
to the calming but now obsolete chatter of vintage typewriters, the
quotes are emblazoned across 560 screens that stretch along the
walls on either side of the lobby.

The algorithm for the piece is specific—quotes starting with
"I" or "you" are paired together and news is categorized into num-
bers, while letters to the editor appear slowly and purposefully, as
if the author were typing them in real time. Several times a day
the screen patterns erupt into undulating waves, letting the viewer
feel a hundred years of news wash over them. The movement and
frequency of the data that sweeps across the screens are directly
affected by current news as well; they draw content from the *New
York Times* in real time and from reader comments on nytimes.com.

Rubin and Hansen compare *Moveable Type* to a living organ-
ism, and they couldn't be more correct. If the *New York Times* were
a being, this would be it: living and breathing news, with the 560
screens acting as lungs and lifeblood.

The piece is accessible to the public during regular business hours.

Ben Rubin and Mark Hansen, *Moveable Type*, 2007, 620 Eighth Avenue

DEAN CORNWELL
The History of Transportation

1º ROCKEFELLER PLAZA
MAIN LOBBY
MIDTOWN

The lobby of 10 Rockefeller is adjacent to the plaza that hosts the *Today Show*'s popular concert series, yet it remains completely under the radar—which is a shame, because it boasts three of the most beautiful murals in New York! Honoring the building's tenant in 1946, Eastern Airlines, the Rockefeller family commissioned illustrator and muralist Dean Cornwell to create an homage to the legacy of transportation, ending with air travel, naturally. Even though Cornwell is relatively unknown now, at the time his illustrations were wildly popular in *Harper's Bazaar*, *Cosmopolitan*, *Redbook*, *Good Housekeeping*, and the like. During his era, Cornwell was as popular as Norman Rockwell!

The History of Transportation takes viewers on a chronological journey of man's mission to travel on land, sea, and air. In gorgeous crimson, gold, and silver, Cornwell's murals unfold in allegorical ornamentation. Two classical goddesses welcome visitors in the central panel, while horses and buggies, steam engines, Wright Brothers-era planes, automobiles, paddleboats, double-decker planes (which had not been invented yet), and even Da Vinci's flying machine swirl around plumes of smoke.

The lobby at 10 Rock may not have the amenities that tourists look for, but it is open to the public and well worth a visit to enjoy this immense mural. The lobby itself reflects the Art Deco style of the original building and leads downstairs to the connecting concourse with a brassy staircase, labeled with early neon signs that list amenities the building had in the 1940s.

Dean Cornwell, *The History of Transportation*, 1946, 10 Rockefeller Plaza main lobby

ISAMU NoGUCHi
Ceiling & Waterfall
666 FIFTH AVENUE
MIDTOWN

The devil's number may be 666, but inside the Fifth Avenue building bearing this address, there is a little slice of meditative heaven. Simply called *Ceiling and Waterfall*, the installation by Isamu Noguchi stretches along the lobby's corridor, and used to create a sound, light, and water experience akin to a soothing relaxation tape. Although the water has since been removed, the installation remains a visual sea of calm.

The undulating metal waves originally echoed the sounds of the trickling water, which masked the traffic and honking outside and served as an aural oasis in the middle of New York. Noguchi's wavy architecture continues above the elevator bays on either side. This piece is one of the artist's later works, and it mixed sound and meditative properties with installation.

Although 666 Fifth is an office building, it is easy to pop through—enter on 52nd or 53rd Street—and take a quick look before security notices you.

An extra tidbit about the building: Stouffer's—yes *that* Stouffer's, of the frozen chicken potpie fame—used to have a fancy restaurant on the top floor of the building, closed in 1996. The Top of the Sixes Restaurant had stellar Midtown views, oak-clad walls, and was extremely popular, serving millions from its opening in 1958.

Isamu Noguchi, *Ceiling and Waterfall*, 1956-58, 666 Fifth Avenue

JAMES TURRELL
Plain Dress
505 FIFTH AVENUE
MIDTOWN

Some New Yorkers get to step inside one of James Turrell's iconic light installations every day, morning cups of coffee in hand. KPF Architects decided to treat the employees working at 505 Fifth Avenue to their daily dose of art, with a site-specific piece that visitors walk right through on their way to the elevator.

Turrell, who is known for glowing explorations of light and space, transformed the lobby into a forced-perspective light box that changes colors twenty-four hours a day. The colors shift frequency and moods, echoing the chaos of Fifth Avenue outside.

James Turrell, *Plain Dress*, 2005, 505 Fifth Avenue

JENNY HOLZER
For 7 World Trade

7 WORLD TRADE CENTER
LOWER MANHATTAN

For decades the magic of New York has been captured in the works of literary greats. Stretching across the lobby of 7 World Trade Center, British artist Jenny Holzer's glowing LED installation scrolls through poems and prose that illustrate New York's amazing history.

Text by Elizabeth Bishop, Allen Ginsberg, Langston Hughes, and Walt Whitman drifts across the sixty-five-foot screen in five-foot-tall letters, taking a full thirty-six hours to cycle through in its entirety. The illuminated piece is viewable from the adjacent park, making the installation accessible to the public, even though it is stationed inside a private, corporate lobby. Sitting on a bench on a warm summer night, watching words on the joys of being in New York City float by, is a magical way to spend an evening.

In 2019 Holzer added poems about New York written by seventeen local children as a permanent amendment to her installation.

Jenny Holzer, *For 7 World Trade*, 2006, 7 World Trade Center

DIEGO RIVERA

Man at the Crossroads

30 ROCKEFELLER CENTER
MIDTOWN

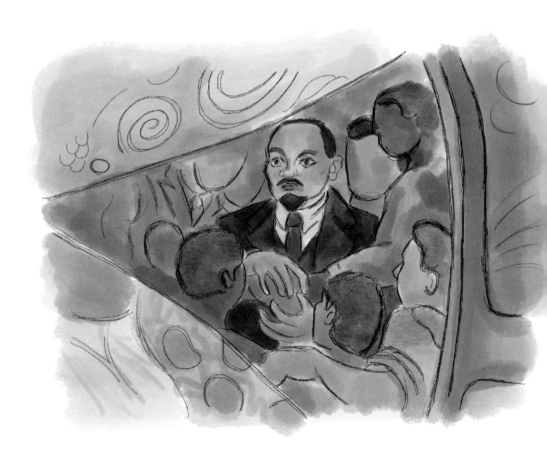

In the lobby of the popular 30 Rockefeller Plaza,

visitors get an eyeful of a giant muscular Titan straddling two columns directly over the entryway. There are three Titans, in fact, and these figures are meant to represent the past, present, and future of man's accomplishments. The massive panoramic piece also features a trompe l'oeil aspect—the giant seems to be looking at you regardless of where you are standing in the room.

The brown and beige mural took the place of an incredible fresco by Mexican artist Diego Rivera, which was destroyed in 1934. Nelson Rockefeller commissioned Rivera to create three murals that showed contemporary social and scientific culture—*Man at the Crossroads*, *The Frontier of Ethical Evolution*, and *The Frontier of Material Development*. The central piece, *Man at the Crossroads*, was supposed to depict capitalism confronting socialism, with capitalism portrayed as the victor. However, Rivera, whose ideology leaned toward communism, decided to execute something other than the agreed-upon sketches.

In the middle of his mural, Rivera painted a figure of Vladimir Lenin holding hands with workers, representing a socialist utopia, opposite a scene of society women playing cards and the lower class fighting the war. The Rockefellers, who were true capitalists, predictably flipped out. Nelson Rockefeller repeatedly asked Rivera to remove Lenin's face. When Rivera would not, the entire piece was chiseled off and replaced by Sert's *Time* three years later.

Jose Maria Sert, *Time*, 1937, 30 Rockefeller Center, lobby, and Diego Rivera, *Man at the Crossroads*, 1933, destroyed

MARC CHAGALL
The Triumph of Music
The Sources of Music

METROPOLITAN OPERA HOUSE
132 WEST 65th STREET
UPPER WEST SIDE

Standing before the fountain in the middle of Lincoln Center is an architecturally orgasmic experience, with the David H. Koch Theater, home to the New York City Ballet, on the right; the David Geffen Hall, home to the New York Philharmonic, on the left; and the Metropolitan Opera House straight ahead, adjacent to the Lincoln Center Theater. The talent of dancers, musicians, and singers can be felt in that plaza, as can the visual splendor of Marc Chagall. Peering through the Opera House's massive windows are two Chagall masterpieces, *The Triumph of Music* and *The Sources of Music*, one in yellow, the other in red, and each spanning thirty by thirty-six feet.

Hanging from the top balcony and extending almost to the lobby floor, the two murals were painted in Paris in 1966 and sent to New York for the opening of the opera house. Chagall also painted the sets and costumes for *The Magic Flute*, performed by the Metropolitan Opera the next year.

Chagall initially intended for the murals to be hung with *The Sources of Music* (the red mural) on the right, but it was hung on the left and the pair have remained as is since they were first installed. The opera used the murals as collateral for a loan in 2009, then estimated to be worth $20 million.

Marc Chagall, *The Triumph of Music* and *The Sources of Music*, 1966, Metropolitan Opera House, 132 West 65th Street

ROY LICHTENSTEIN
Mural with Blue Brushstroke

787 SEVENTH AVENUE
MIDTOWN WEST

The seventy-foot-tall Roy Lichtenstein mural
that dominates the public exhibition space at AXA Equitable is
one of the artist's largest and serves as a veritable highlight reel of
Lichtenstein's works. Called *Mural with Blue Brushstroke*, the piece
was commissioned in 1984 to complement the Whitney Collection—which was originally displayed in the building—and includes
bits and pieces from some of Lichtenstein's most popular works
from the past. The familiar beach ball from *Girl with Ball*, as well as a
sunrise, waterfall, and hand with sponge, are collaged together like
a "best of" representation of Lichtenstein's work from the 1970s.
Lichtenstein and six assistants projected slides directly onto the
wall in the building and painted the colorful piece over the course
of six weeks.

The massive painting, which can be enjoyed from inside as well
as from the street, is part of a fantastic permanent collection that
includes pieces by James Rosenquist, Sol LeWitt, Agnes Denes, and
Barry Flanagan.

Roy Lichtenstein, *Mural with Blue Brushstroke*, 1984-86, AXA Equitable
Corporate Lobby Collection, 787 Seventh Avenue

SOLOW COLLECTION

9 WEST 57th STREET
MIDTOWN

If you've ever walked by the Solow Art & Architecture Foundation's ground floor gallery space on 57th Street, you've probably noticed that it wasn't open. No, you didn't come on a weird day, the director wasn't out to lunch, and the hours aren't kept on the weekends. The truth is, it's never open—ever.

It is only through the expansive glass windows and under the vibrant glow of the track lights that the incredible paintings inside are revealed to the public—works by Francis Bacon, Franz Kline, Henri Matisse, Balthus, Alberto Giacometti, and Henry Moore. The impressive collection belongs to Sheldon Solow, the real estate magnate who owns the entire building—and placed the *Moonbird* outside of its 58th Street entrance.

No one really knows why Solow keeps his art collection here, for his eyes only, or why two guards work there, keeping watch over no one. But at least the billionaire has graced us with the presence of his collection—even if it is only viewable through plate glass.

Solow Collection, 9 West 57th Street

CHAPTER FIVE

ARTISTS' HOMES & HAUNTS

Gazing at paintings that speak to us in museums, we can easily forget there was an actual person, one who traversed the same New York streets we do, behind each work. This city was once crawling with famous artists who made it their home—once upon a time when studios and apartments were more affordable for the working creative class.

There's nothing like experiencing a place from the perspective of your heroes. Take a stroll back in time, past your favorite masters' former abodes and studios, allowing yourself a moment to imagine the New York they saw when they'd walk out of those doors each day. Step inside Donald Judd's sprawling Soho residence as he left it; walk by the stable house where a young Basquiat lived, worked, and tragically died; or pay homage to Louise Bourgeois's town house, where she would often open her studio doors for young artists to bring their portfolios.

These artists and the New York they lived in may be long gone, but the inspiration from treading in their footsteps can be experienced by those willing to look for it.

ANDY WARHOL
Residence
1342 LEXINGTON AVENUE
UPPER EAST SIDE

Andy Warhol was synonymous with the Down-

town scene in Manhattan, but the visionary called the elegant and conservative Upper East Side home for many years. Built in 1889 by Plaza Hotel architect Henry Hardenbergh (who also designed The Dakota), this modest town house was where Warhol lived from 1959 until 1974. In the early 1960s the ground floor was used as a studio, in which Warhol made his early Brillo Boxes and Campbell's Soup Can pieces. This space was the precursor to the first "Factory."

When Warhol and his mother moved into the town house, he was paying bills as a freelance illustrator while developing his signature Pop art style in the studio downstairs. It was here that he wrote the children's book *25 Cats Name Sam and One Blue Pussy*, which included his drawings of cats, with calligraphy penned by his mother. This now-famous book was not just an early project, but also his reality—an adorable interpretation of his life as art.

Along with his mother, Warhol lived with twenty-five furry feline roommates—all named Sam. The cast of cats began when Warhol sought a companion for Hester, his first cat, and grew until the brethren of Sams eventually reached twenty-five. The Sams enjoyed the sprawling four stories of the town house, likely never leaving Hester without company—and often found their way into Warhol's illustrations.

Andy Warhol's Town House and Cats, 1342 Lexington Avenue

ANDY WARHOL
The Factory

231 EAST 47th STREET 860 BROADWAY

33 UNION SQUARE WEST 22 EAST 33rd STREET

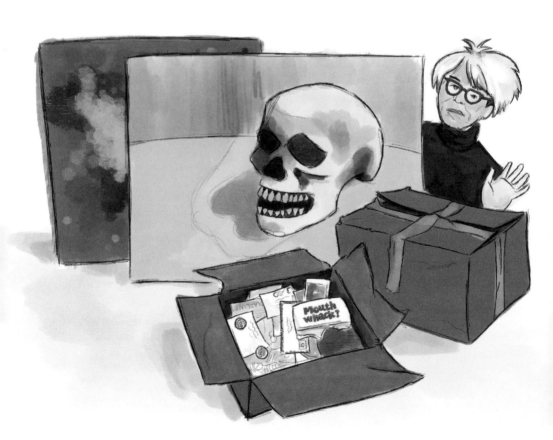

By the 1960s, Andy Warhol had left commercial

illustration and begun his transformation into the innovative art enigma who changed the world as we know it. Every star needs a stage, and so he turned his art studio into the social epicenter famously known as The Factory.

The Factory had four iterations over the course of Warhol's life. The first was in a now razed building on East 47th Street. The rent was just $100 a year, and model Billy Name decorated the walls with tinfoil, gaining the space the name The Silver Factory. In this space, from 1962 to 1967, Warhol groupies and friends became known as the Warhol Superstars, spending their days and nights consuming copious amounts of amphetamines and barbiturates while making films that launched their fifteen minutes of fame.

When The Silver Factory was torn down in 1967, Warhol and his crew headed downtown to be closer to their favorite hangout, Max's Kansas City. Warholite Paul Morrissey found Factory number two, on the sixth floor of the Decker Building on Union Square West.

While the first Factory was where Warhol shot most of his films, the second location became a production house for many of his now-famous silkscreen paintings. Warhol enlisted the Superstars who had starred in his films to help mass-produce silkscreens, in a true "factory" setting that would evolve into nightly parties.

In 1968, Valerie Solanas, author of the S.C.U.M. Manifesto (Society for Cutting Up Men) shot at Warhol three times in this space, because she felt he was taking control of her screenplay away from her. The third shot finally hit, going through his left lung, spleen, stomach, liver, esophagus, and finally his right lung. Warhol was pronounced clinically dead—and was then revived—but

had health issues for the rest of his life. Solanas also shot art critic Mario Amaya, who was visiting The Factory on the fateful day.

Warhol installed video cameras in The Factory in 1970 as a means of security, but also to document happenings around the studio. Yet he still felt unsafe, so he moved the studio a block across Union Square to a higher-security building. In this location, The Factory transformed from being a social center to a place where Warhol, now more famous than ever, could find solitude. Bulletproof doors, closed-circuit surveillance, and secret rear exits ensured that Warhol felt safe and could monitor who was allowed in and out. He also tried to deter the obsessed fans who would call over and over by hiring only foreign receptionists. More than one incessant caller was thwarted by repeatedly having to spell out their name to receptionists who could hardly speak English.

During the ten years The Factory was in this location (1974–1984), Warhol created the boxes of *Time Capsules* (which now reside at the Warhol Museum in Pittsburgh), the Skull paintings, and the less popular piss paintings.

In 1984 Warhol moved The Factory one last time, to East 33rd Street. No longer wanting his studio to be the center of his social life, Warhol was seen more at nightclubs around New York and Hollywood. He created his famous silkscreens of celebrities there, and at a studio at 158 Madison Avenue, until his death in 1987.

Andy Warhol's Factories
1962–1967 231 West 47th Street, fifth floor (razed)
1967–1974 33 Union Square West, sixth floor
1974–1984 860 Broadway
1984–1987 22 East 33rd Street

CARNEGIE ARTIST STUDIOS

881 SEVENTH AVENUE
MIDTOWN WEST

High above the famed recital hall built by Andrew

Carnegie, the Carnegie Artist Studios once fostered New York musicians, painters, sculptors, actors, architects, and writers, offering live/work lofts beginning in 1895. Started by Carnegie himself to bring in alternative revenue while fostering artists, the unique living space was a creative center for more than one hundred years, until residents were evicted in 2011.

The studios were a hotbed of artistic genius: Leonard Bernstein composed here; Marlon Brando, Marilyn Monroe, Paul Newman, Jane Fonda, and Robert Redford lived and rehearsed their lines here; Charles Dana Gibson created the Gibson Girl here; Elia Kazan lived here before selling out his supposed communist friends; and Duke Ellington, Count Basie, and Judy Garland hung out here. The lofts were immortalized right before they were closed in former resident Josef Birdman Astor's documentary *Lost Bohemia*, as well as the documentary *Bill Cunningham New York*, about that legendary resident. In that film Cunningham was often accompanied by a longtime resident, photographer Editta Sherman, who lived in the lofts for more than sixty years and photographed Hollywood's elite there throughout her career.

The lofts were turned into offices and educational space in 2011, ending the tradition of affordable living places for artists.

Carnegie Artist Studios, 881 Seventh Avenue

CHAIM GROSS
Studio, Foundation & Museum
526 LAGUARDIA PLACE
GREENWICH VILLAGE

Just off Washington Square Park is a peek into the life of a New York artist one hundred years ago. Late in his life, artist and Sculptors Guild founder Chaim Gross bought a beautiful 1830s town house on LaGuardia Place. He converted its four floors into a single home—a dream live/work space complete with a grand sculpture studio to create in.

Gross designed the studio to double as an inspiring exhibition space, with inlaid wood floors and a massive row of modernist skylights for working by sun-drenched daylight. Today, the classic home serves as a house museum of Gross's wood and marble sculptures, which span from the 1920s to the 1980s. Aside from his own work, the house also has Gross's personal art collection on display, with pieces by Willem de Kooning and Avery Hartley, as well as an extensive European, American, and African sculpture collection.

Gross's extraordinary studio has been renovated to its original splendor for visitors to enjoy. The foundation is only open Thursday and Friday between 1 and 5 p.m., so take a mental health day and get inspired.

Chaim Gross, Studio, Foundation, and Museum, Renee & Chaim Gross Foundation, 526 LaGuardia Place

COENTIES SLIP GROUP

COENTIES SLIP
between PEARL & WATER STREETS

LOWER MANHATTAN

In the 1950s a group of museum-caliber artists

settled into the old sail-making factories in the shadow of the Brooklyn Bridge, on a small strip along the East River called Coenties Slip. Robert Rauschenberg and Jasper Johns were the first to move in, attracted by the high ceilings and open industrial lofts. Soon other artists, like Ellsworth Kelly, Agnes Martin, and James Rosenquist, followed suit and shifted to the nautical neighborhood by the East River, far from the Greenwich Village scene where artists often worked in the confines of their row house apartments.

Coenties Slip has been steeped in the history of New York since the city's inception. In the seventeenth century, the shipping center was home to the City Hall of New Amsterdam, and in the eighteenth and nineteenth centuries it was the site of New York's first publishing houses, bringing writers like Walt Whitman and Edgar Allan Poe to the industrial seaside neighborhood.

By the 1950s, the area remained mostly industrial. Wanting to completely differentiate themselves from the Abstract Expressionists, the Coenties Slip Group began to develop the precursors to Pop art and Minimalism within their lofts, drawing inspiration from the uninterrupted river views and nautical relics they found in their buildings. Although the artists resided near each other, their group name was purely geographical. They did not form a particular art movement together, instead acting as a community of support and critique as each member forged an individual artistic path.

The area has since been taken over by the tourist-heavy South Street Seaport. Most of the buildings the artists lived in have been torn down, except for their favorite bar, the historic Fraunces Tavern, which was also a meeting place for the Sons of Liberty and a hangout during the Revolutionary War.

Coenties Slip Group, Coenties Slip between Pearl and Water Streets

DIANE ARBUS
Westketh Artists Community
55 BETHUNE STREET
GREENWICH VILLAGE

In 1971, pushed to the point of extreme depression, forty-eight-year-old photographer Diane Arbus took her own life, consuming a heavy dose of barbiturates and then slashing her wrists in her live/work studio at Westbeth Artists Community in the West Village. The photographer, whom we know best for taking pictures of the fringes of society in the 1960s, grew more famous after her death (like many artists), with the Museum of Modern Art staging a retrospective of her work a year after she died.

Since 1970, the Westbeth Artists Community has fostered artists in New York, offering affordable housing and studios for creatives in visual and performing arts. (It is also one of the first adaptive reuse projects, as it was formerly the Bell Laboratories, where one of the first versions of the television was invented.) After renovations by architect Richard Meier, Westbeth opened to 384 artists of all persuasions to live and work. The resident wait list had been closed since 2007, but was reopened in 2019. As of 2014, the average rent, including utilities, was $800 a month, about one-quarter the market rate.

Diane Arbus, Westbeth Artists Community/site of her suicide, 55 Bethune Street

DONALD JUDD
Residence & Studio
101 SPRING STREET
SoHo

Donald Judd's largest installation expands across five stories, and is also known as his former home. Judd bought this historic cast-iron building on Spring Street in 1968, in the industrial neighborhood that was then known as the Cast Iron District. Like many artists, Judd sought the sprawling space as an inexpensive place to live and work. He and his family stayed at 101 Spring until the growing popularity of the area pushed him to the more isolated Marfa, Texas. Judd made much of his Minimalist work at this location, while also unknowingly preserving one of Soho's single-use buildings from the 1870s.

It was also here that Judd developed the concept of the permanent installation as a living space. In much the way Frank Lloyd Wright held the all-encompassing belief that he needed to design the exterior, interior, and furnishings of a home to exact his vision, Judd believed that the placement of artworks, furniture, and decor were linked—and he arranged them meticulously to create one cohesive art experience. Judd died in 1994, and his art and furnishings in the Spring Street building have remained exactly how he placed them. The ground floor serves as a rotating gallery, exhibiting artists who had touched Judd's life.

The renovated Judd Foundation opened to the public in June of 2013.

Donald Judd, Former Residence and Studio, 101 Spring Street

EDWARD HOPPER
Studio
3 WASHINGTON SQUARE NORTH
GREENWICH VILLAGE

Edward Hopper's habitual solitude permeates

his paintings, infusing the empty interiors and city scenes that capture the unique loneliness often felt in densely populated urban areas. Hopper's depression and negative attitude fueled his art-making throughout his life, and eventually his work found an audience. Hopper loathed having to work for a living and preferred to focus on "real art" rather than taking commercial illustration jobs to get by like his contemporaries. He was known to sit for days in front of an empty canvas, stuck without inspiration, whiling away the hours until an idea came to him.

Despite this, his negativity didn't weaken his career. He finally gained recognition in 1923, married his muse, and sold a slew of paintings to museums during the Depression. He painted his most famous work *Nighthawks*—a timeless restaurant scene that epitomizes his views on human isolation and urban emptiness—in this space in 1942.

Hopper and his wife, both introverts, lived in Cape Cod and this studio in Washington Square Park, which is now part of NYU, from 1913 until Hopper's death in 1967. The top-floor studio was modest to say the least, with no heat and no private bath. Hopper insisted on living there because he was told his hero, painter Thomas Eakins, had painted there.

Hopper's wife Josephine gave his entire collection to the Whitney Museum before she died, ten months after her husband.

Edward Hopper Studio, 3 Washington Square North

GAINSBOROUGH STUDIOS

222 CENTRAL PARK SOUTH
MIDTOWN WEST

Today Central Park South brings to mind a tangle

of tourists, horse carriages, and expensive hotels—a far cry from the sort of place where artists would or could settle. But in 1908, a group of artists wanted to be inspired daily by the park's beauty and demanded to have their own uninterrupted Central Park northern light. An artist named V.V. Sewell complained that no one understood how hard it was to find a decent studio in New York (ha ha!), and so together with a group of artists formed Gainsborough Corporation named after eighteenth-century British painter Thomas Gainsborough. Under Sewell's leadership the group banded together to build an epic studio and apartment building for themselves.

And build it they did. The Gainsborough Studios stands out among the other high-rises along the block. The lower levels are decked with intricate Victorian stone carvings, including a frieze by Austrian sculptor Isidore Konti called *Procession of the Arts*, and a bust of Thomas Gainsborough himself. The top floors have an ornate Edwardian tile mural in bright colors, made from eighteenth-century German pottery from artisan Henry Chapman Mercer in Doylestown, Pennsylvania.

The "artist studio" units are duplexes along Central Park South, each boasting eighteen-foot ceilings—a rarity at the time, achieved by filing the structure as a hotel rather than an apartment building. The north-facing studios were filled with light, rich mahogany and oak woodwork, ornate balconies, art tile fireplaces, built-in

cabinets, and leaded-glass doors. The luxury building hosted well-to-do men and women artists over the greater part of the century, who shared kitchen areas, a reception area, a laundry, and a private restaurant.

In 1924, an interior decorator named Paul C. Leatherman held a sculptor named Helene M. R. White captive in his first-floor studio. Other than that, the biggest scandal is the current cost of an apartment there.

Gainsborough Studios, 222 Central Park South

GEORGE BELLOWS
Residence & Studio
146 EAST 19th STREET
GRAMERCY PARK

In the early 1900s, East 19th Street was a miniature artist enclave, with residents Robert Winthrop, Ethel Barrymore, Helen Hayes, and F. Scott Fitzgerald all living in close proximity to one another. The block was transformed into unique arty facades, complete with eclectic stained glass and tiles largely by architect Frederick Sterner. Across from Winthrop's House of Fantasy was the town house of the great New York painter George Bellows. Bellows converted the attic of his home into an art studio, where he developed his signature paintings showing the harshness of city life, including both the struggles of the working class and ease of the upper class.

Although Bellows was wildly successful, his pieces were often criticized for being "too real" in his depiction of social and political themes—the critics felt that the truth hurt too much. Bellows lived and worked here with his wife and daughters until his death due to complications from appendicitis at age forty-three in 1925.

George Bellows, Residence and Studio, 146 East 19th Street

GEORGIA O'KEEFFE & ALFRED STIEGLIETZ Residence

525 LEXINGTON AVENUE
MIDTOWN EAST

In 1916 Georgia O'Keeffe heard that some of her

charcoal drawings were on display at a gallery in New York, which came as a complete surprise to the young artist. She made her way to 291 gallery to chastise the director for showing her work without her knowledge, only to find the owner was renowned Photo-Secessionist Alfred Stieglitz. Stieglitz was in a loveless marriage at the time, but by 1917 he and O'Keeffe had fallen into a deep and passionate love that would last his lifetime—and heavily influence and foster both artists' practices.

By 1918 Stieglitz had left his wife Emmeline and moved his young lover—he was twenty-three years O'Keeffe's senior—from Texas to New York. In 1925 the pair settled on the thirtieth floor of what is now the Marriott—then known as the Shelton Hotel. O'Keeffe, who had worked mostly in abstract art, began painting the growing skyline she could see from her window. It was here that she painted the Art Deco gem a few blocks away, *Radiator Building—Night*, just two years after moving to the Shelton. Many believe the piece doubles as a portrait of the couple, with O'Keeffe as the Radiator Building and Stieglitz as the Scientific American Building, painted with a glowing red stripe.

Just as he did with his previous wife, Stieglitz began cheating on O'Keeffe with an even younger woman—the twenty-two-year-old Dorothy Norman. Stieglitz and O'Keeffe had the apartment at the Shelton Hotel until 1929, at which point O'Keeffe began spending much of her time in New Mexico, away from her husband's indiscretions.

Georgia O'Keeffe and Alfred Stieglitz Residence, 525 Lexington Avenue

JACKSON POLLOCK

Residence & Studio

46 CARMINE STREET
GREENWICH VILLAGE

In 2011 the apartment of art history's favorite alcoholic, Jackson Pollock, came up for sale on Carmine Street. Billed as a "penthouse," the 800-square-foot crash pad is more like a top-floor walk-up, but with four light-bleeding skylights one can easily see why Pollock chose to live and paint here. The apartment was selling for $1.4 million, far far less than any other Jackson Pollock you could get your hands on. You can imagine Pollock stumbling home from the nearby Cedar Tavern, banging his head on the angled ceiling before passing out in bed or sobering up in the tiny bathroom's Japanese soaking tub.

The building itself is steeped in history, once owned by renowned glove-slapping-Alexander-Hamilton dueler and third vice president Aaron Burr, who lived in New York for much of his law career and returned to buy this building after he fled to Europe following his arrest—and acquittal—for treason.

Jackson Pollock (and Aaron Burr), Residence and Studio, 46 Carmine Street, top floor

JASPER JOHNS Studio

225 EAST HOUSTON
LOWER EAST SIDE

By the time Jasper Johns bought the former Provident Loan Society building on the corner of Houston and Essex, his Minimalist approach to painting ordinary, everyday objects had already begun to influence Andy Warhol, Claes Oldenburg, and Roy Lichtenstein. Johns transformed the former bank, built in 1912, into a vast studio and living space, with the bank's large windows casting ample daylight onto his work area.

At "The Bank," Johns worked on his best known pieces of the late 1960s, including the three major series of works: flags, targets, and numerals. By the 1970s, he had reinvented himself, delving into geometric lithographs, monochromatic works, and crosshatch patterns. He also began splitting his time between the then-gritty Lower East Side and a house upstate in Stony Point, New York. By the 1980s, Johns was mostly based in his upstate abode, where he once again reinvented his oeuvre, painting more direct, emotional, even autobiographical work. He still stayed at The Bank when in the city, but used it primarily as a storage warehouse for his large artworks.

In 1988 Johns departed permanently to Connecticut, and the space became a series of nightclubs, which have since closed. The building was unable to gain landmark status and is slated to be topped with a twelve-story residential project.

Jasper Johns, Studio, 1967–88, 225 East Houston

JAY MAISEL
Residence & Street Art

190 BOWERY
NOLITA

This historic mixed-used building on Spring and

Bowery was shrouded in mystery until it was sold in 2015. The exterior was a major street art target, consistently hit since the dawn of graffiti in the 1970s. Next to the veritable outdoor gallery of leading street artists were homeless people trickling over from the nearby Bowery Mission, constantly camped out on the long-unused corner stoop. For years, the building's exterior thrived as a center for guerrilla artists, as well as a reflection of the rough days of the Bowery.

Many thought the impressive building was abandoned, but its seventy-two rooms were a unique private home belonging to advertising photographer Jay Maisel, his wife, and their daughter until 2015. He bought the building for $102,000 in 1966 and sold it for $55 million. Maisel photographed his neighborhood for fifty years, ran his photography studio in the former bank's floors, and even rented one level to Roy Lichtenstein the first year after he moved in.

Built in 1898, the Germania Bank Building is a Beaux-Arts mansion of 35,000 square feet spread over six floors, sitting in the center of what was New York's Little Germany neighborhood. Once the golden era had passed, the neighborhood became known as a skid row for decades. The building was flanked by the Bowery Mission, panhandlers, and industrial storefronts when Maisel moved his family in in 1966—all of which remained when CBGB opened across the street seven years later. The Bowery Hotel and the New Museum changed all that, turning the area into a mix of high-end venues, restaurants, and shops, still within a block of the homeless shelter. Maisel decided to change with the times and sold his unconventional home, asking its new owners to allow street artists to continue to leave their marks on the ground level.

Jay Maisel, Artist Residence and Street Art Center, 190 Bowery

JEAN-MICHEL BASQUIAT
Residence & Studio

57 GREAT JONES STREET
EAST VILLAGE

Noho's 57 Great Jones Street has had many lives

over the past 150 years: as a horse stable, a fruit seller, a scandalous mob hangout, and a swanky referral-only restaurant (its current iteration). But, more importantly, it has been a place where art history was made. The modest brick building, with its half-moon windows, was where native New Yorker Jean-Michel Basquiat lived and worked until his death at that cursed age of twenty-seven. Basquiat's life was short but rich. He started out as a graffiti artist writing SAMO all over the East Village, then later joined the punk rock scene with Vincent Gallo and their band Gray. Gray regularly played Max's Kansas City, CBGB, and Mudd Club, allowing Basquiat to meet the downtown art stars who helped him get cast in the movie *Downtown 81*, as well as seminal East Village band Blondie's "Rapture" video.

Moving on to create his legendary Neo-Expressionist paintings, Basquiat met Andy Warhol in 1982 and started collaborating with his new famous friend. It was here, in a loft in the building then owned by Andy Warhol, that Basquiat made the work that gallerists Annina Nosei, Larry Gagosian, and Mary Boone clamored over. It was also here that, not long after Warhol's death, Basquiat died of a heroin overdose on August 12, 1988.

During the Civil War, the building was a horse stable and was later renovated into a dance hall and saloon frequented by the Italian mob in the early 1900s. In 1905 one gangster "slipped and fell on a bullet" inside (seriously) and lived . . . for just two days before someone else shot him.

Jean-Michel Basquiat, Residence and Studio, 57 Great Jones Street

KEITH HARING

Mural AT THE FORMER
School of Visual Arts Gallery
260 WEST BROADWAY
TRIBECA

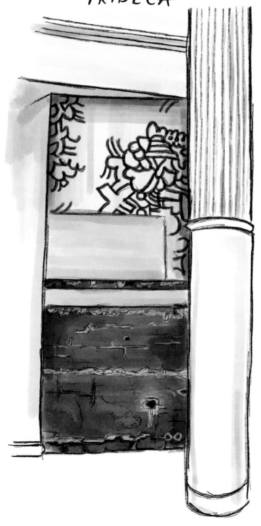

When realtors were renovating this private,
8,200-square-foot "maisonette" in Soho, they accidentally
unearthed a stunning piece of art history. Lurking behind a wall
was a long-forgotten mural by Keith Haring, painted during his
college years. Back in 1978, during his days at the School of Visual
Arts, Haring created the mural as part of a student exhibition,
when the now-sprawling home was used as a student gallery. The
gestural, abstract shapes in Haring's student work paved the way
for the signature dancing figures he painted on the streets in the
late 1970s.

The mural was executed in shoe polish and alcohol, and the
realtors had originally hoped to move it to a museum or private
collection. But the composition's temperamental nature meant
it would be reduced to rubble if disturbed, so it remained and
has become an amazing part of a living space that most of us can
barely even dream of! In the nineteenth-century American Thread
Building, the residence includes double-height ceilings, insane
windows, and, with the handiwork of Haring, the knowledge that
a brilliant artist once stalked the halls of their home, creating a
mural that clearly shows the beginnings of all his work to come.

Keith Haring, College-era Mural, 260 West Broadway, private residence

LOUISE BOURGEOIS
Residence & Studio
347 WEST 20th STREET
CHELSEA

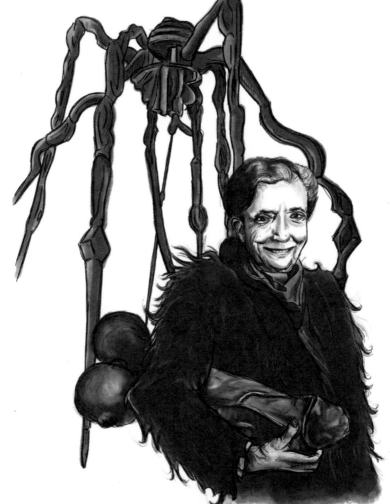

The block of 20th Street where Louise Bourgeois

once lived is an idyllic pocket of serenity, smack in the middle of Chelsea. The brownstones that line the south side of the block were mostly built in the 1850s and face the beautiful campus of the General Theological Seminary of the Episcopal Church on the north side. Bourgeois and her husband Robert Goldwater bought the brownstone in 1962 as their home, and when he died in 1972, Louise converted some of the living areas into studio space. The sculptor, who was affiliated with the Abstract Expressionist, Surrealist, and feminist movements, created many of her important works at her studio until her death in 2010 (at ninety-eight!), but also used her house as an open-door salon for established and young artists. Each week Bourgeois hosted Sunday salons, inviting artists, writers, and other creative types of all ages to mix and mingle in her historic home. On occasion, she'd also open her door to young artists for portfolio reviews. These eager creators could be seen lining up outside the building, waiting for her sometimes harsh crits of their latest work.

Bourgeois became a New York staple not long after she moved to the city with her husband in the 1940s and began creating sculptures that evoked tragic themes of betrayal, anxiety, and loneliness—which are said to stem from her father's affair with her governess—there.

Next time you walk down the beautiful block of 20th Street en route to the gallery district, pay a little homage to Bourgeois, who did so much for the art world out of the goodness of her heart. The town house is owned by Bourgeois's Easton Foundation, which hopes to one day open the sanctuary to the public.

Louise Bourgeois, Residence and Studio, 347 West 20th Street

MARC CHAGALL
Residence

4 EAST 74th STREET
UPPER EAST SIDE

Modernist artist Marc Chagall only lived here
for seven years, but his lasting touch can be felt on New York City.
His gorgeous murals at Lincoln Center are as famous as the Metro-
politan Opera itself, while his massive stained-glass *Peace Window*
at the United Nations building has inspired visitors since the artist
gifted it himself in 1963.

Marc Chagall, a Russian Jew by origin, and his wife moved to
New York in 1941, fleeing the Nazi occupation of Paris. Together
they lived in the top-floor apartment of this Beaux-Arts building at
4 East 74th Street, a stone's throw from Central Park. Here, Chagall
spent his days reworking the canvases he had brought from Europe
and his evenings walking miles around the city with his wife. They
lived here happily until her death in 1944, decorating the apart-
ment like a Paris studio.

Marc Chagall, Apartment, 4 East 74th Street

MARCEL DUCHAMP
Residences & Studios

33 WEST 67th STREET 246 WEST 73rd STREET
34 BEEKMAN PLACE 210 WEST 14th STREET
1947 BROADWAY 28 WEST 10th STREET
80 EAST 11th STREET

During his lifetime, visionary Surrealist, Cubist,

and Dadaist Marcel Duchamp took up residence in New York many times. In 1915, after the declaration of World War I, he fled Europe after being deemed unfit to enlist due to a heart murmur and moved into a studio owned by arts patrons Louise and Walter Conrad Arensberg at 33 West 67th Street. Duchamp found he was already a celebrity when he arrived in New York, thanks to the splash his piece *Nude Descending a Staircase No. 2* made at the Armory Show two years before. He quickly developed an exclusive social circle which included the Arensbergs, actress Beatrice Wood, and artists Man Ray and Francis Picabia. Despite being the toast of New York, Duchamp made extra money by teaching French for $2 a lesson for the first year he lived in the city. Can you imagine being taught by him?

The Arensbergs became lifelong friends of Duchamp, and rather than charge him rent for his two-year stay, they traded him for *Bride Stripped Bare by Her Bachelors, Even*, or what is known as *The Large Glass*—now on permanent display at the Philadelphia Museum of Art. The details of the piece were made in Paris and brought with his move, but the piece came together bit by bit in his new home in New York. The construction was so meticulous Duchamp could only work on it for two hours a day before needing a break! This studio is also where he created the infamous readymade *Fountain* by writing "R. Mutt 1917" on a urinal. The urinal was a standard Bedfordshire model from the J.L. Mott Iron Works, located at 118 Fifth Avenue. Duchamp later lived at two other apartments before leaving the city for Paris and Buenos Aires in 1918.

In 1920, he returned to New York and lived at 246 West 73rd Street, bringing the piece *Paris Air*, a glass ampoule filled with genuine

Paris air—or maybe nothing?—with him. He quickly caught up with his old friend Man Ray, and along with Katharine Dreier formed the Société Anonyme, which organized and promoted Cubist and abstract art shows for twenty years.

He skipped back to Paris in 1923 until, fleeing World War II, he came back to New York in 1942, settling into 210 West 14th Street. It was here that, using found objects from his walks around the neighborhood, Duchamp secretly began constructing *Étant donnés*, which he worked on for twenty-two years. For the remainder of his life, Marcel Duchamp traveled extensively, but kept his home base in New York. He continued to work on *Étant donnés* first on West 10th and then in his final studio at 80 East 11th Street, a space he kept until he died in 1968. It is said that he walked the installation piece by piece down Broadway when moving to this final studio.

Duchamp intended for the piece to be revealed after his death, a posthumous gift to the world. It was left in his studio in room 403, and when he died was disassembled and moved for permanent display at the Philadelphia Museum of Art. The building, the former St. Denis Hotel, had its own rich history including guests like Abraham Lincoln, Sarah Bernhardt, Alexander Graham Bell, Susan B. Anthony, Ulysses S. Grant, and Mark Twain, and was fully demolished to make way for a twelve-story glassy condo building during the editing of this book.

Chasing Marcel Duchamp around New York:
1915–1917 33 West 67th Street | 1917–1918 34 Beekman Place
1947 Broadway | 1920 246 West 73rd Street
1942 210 West 14th Street | 1959 28 West 10th Street
1965 80 East 11th Street (demolished 2019)

PEGGY GUGGENHEIM
Residence

JACKSON POLLOCK Mural
155 EAST 61st STREET
UPPER EAST SIDE

After separating from her estranged husband
Max Ernst in 1943, super collector Peggy Guggenheim moved into this duplex apartment and quickly turned her new address into *the* gathering place for the top tier of New York's art world. Her curatorial eye turned to Jackson Pollock, whom she had "discovered" working as a janitor at the Museum of Non-Objective Painting (later the Guggenheim Museum). Guggenheim commissioned Pollock to create a giant mural piece for her new entryway. At first she wanted a mural directly on the wall, but her buddy Duchamp convinced her to get a work on canvas.

An early example of Pollock's work, *Mural* is a series of controlled swirls and forms—a precursor to his iconic drippy action paintings. At twenty feet long and eight feet high, the painting was a little bigger than Guggenheim had anticipated. After a day of difficult installation, the piece was finally fitted into her entryway. Guggenheim invited the best of her contacts to come over for an unveiling reception and celebration.

Pollock, being a famous alcoholic, also had a habit of urinating . . . in public. Pollock later bragged that during the unveiling party, he showed up very drunk, walked over to the fireplace, unzipped his pants, and relieved himself right there in front of everyone.

Guggenheim later donated Pollock's *Mural* to the University of Iowa Stanley Museum of Art.

Peggy Guggenheim, Residence, Jackson Pollock's *Mural*, 1943, 155 East 61st Street

PEGGY GUGGENHEIM & MAX ERNST
Love Nest

440 EAST 51st STREET
UPPER EAST SIDE

Romantic entanglement between artist and collector

can make for a messy and imbalanced relationship. Peggy Guggenheim famously did it over, and over, and over again, claiming to have had almost one thousand lovers in her lifetime. Yet despite having an insatiable lust for the creative set, Guggenheim only married two men: poet Laurence Vail and Surrealist master Max Ernst. Ernst and Guggenheim had a tumultuous marriage and lived together for a time in this lavish town house on the Upper East Side.

Guggenheim met Ernst in 1938, when she was rapidly building her collection of Dada, Cubist, and Surrealist works at her London gallery. She then went to Paris with plans to open a museum, buying a painting a day for its collection, while starting an affair with Ernst. They married in 1942 and fled the German-occupied Paris for New York. Shortly after, she opened another gallery and moved into this love nest, which was the center of the New York art world for several years.

Marital bliss was short-lived, as the pair separated a year after marriage and eventually divorced in 1946 after Ernst had an affair with his next wife, Dorothea Tanning, whom Guggenheim had curated into an exhibition. After the divorce, Guggenheim fled to Venice, which became the home to her museum, while Ernst married Tanning and moved to Sedona, California, where they lived until his death in 1976.

Perhaps the couple was doomed from the get-go, as their town house was thought to be the place Nathan Hale was hanged during the Revolutionary War.

Peggy Guggenheim and Max Ernst, 440 East 51st Street

PIET MONDRIAN
Residence

345 EAST 56th STREET
MIDTOWN EAST

Known for his abstract geometric paintings and

as a founder of the De Stijl art movement, Piet Mondrian settled in New York in 1940 after fleeing the London Blitz during World War II. The Dutch artist moved into this small apartment, where he let the influence of Manhattan change the direction of his work.

Growing up in the Netherlands, Mondrian then bounced between his home country, Paris, and London. He developed his signature "lozenge" paintings, which were composed of perpendicular black lines and colored squares, and were sometimes painted by turning his canvas askew to create a diamond shape.

Once in New York, Mondrian became influenced by his new surroundings—hot jazz music and the shimmering lights of Broadway. His stoic works began to have more movement, and his precise black lines shifted into bold red, blue, and yellow. With his newfound love of jazz, coupled with the bustle of Manhattan, Mondrian began creating paintings with more vigor and energy than his previous works. *Broadway Boogie Woogie*, which can be seen nearby at the Museum of Modern Art, pushes his classic geometric works into a series of abstract squares that seem to glitter and gleam like the nearby theater lights.

Mondrian created lively works here for three years until the fall of 1943, when he moved nearby to 15 East 59th Street, living there until his death a few months later in 1944.

Piet Mondrian, Artist Residence, 345 East 56th Street

ROBERT WINTHROP CHANLER
House of Fantasy
Giraffe Facade

147 EAST 19th STREET
GRAMERCY PARK

The giraffed archways of 147 East 19th Street

were once the entryway to the social center of the high society arts community in New York. The home was the residence of Robert Winthrop Chanler, a mural artist who came from a long line of New York blue bloods—with family lines meshed in the Astors, Stuyvesants, Delanos, and Winthrops. After the requisite stint in Paris studying art in the 1890s, Chanler moved to New York and set up shop, famously hanging his work at the first Armory Show in 1913.

His main patrons were also top society: Gertrude Vanderbilt Whitney and Mai Rogers Coe. Both of those grandes dames commissioned floor-to-ceiling murals in their Long Island mansions. Along with other arty society guests, they'd pass under the giraffes to join the company of caged sloths and monkeys at Chanler's Gramercy Park home, as ravens and toucans squawked along with the chatter, while angelfish, crabs, seahorses, eels, and turtles intermingled in his private pool. A fantastical scene at that!

Chanler echoed these incredible evenings by painting elaborate animal screens, which were popular with his patrons, and in his own home. His love of animals is evident even on the exterior of his town house, including the giraffes that welcomed guests to his House of Fantasy and can still be seen today.

Robert Winthrop Chanler, House of Fantasy/Giraffe Facade, 147 East 19th Street

SALMAGUNDI CLUB
47 FIFTH AVENUE
GREENWICH VILLAGE

Housed in the only remaining privately owned

brownstone on Fifth Avenue below 124th Street, the Salmagundi Club is a look into an artists' social life of 1917. Founded in 1874, the private club was originally called *New York Sketch Class* and served as a gathering place for artists—or should I say *male* artists—to stage drawing classes and exhibitions and to discuss ideas and artist theories. The artists soon figured out that extending membership to collectors would help to sell their paintings, so the club was renamed Salmagundi, meaning "many ingredients," after Washington Irving's papers—and also referring to a stew once served in the club's café.

For over one hundred years, the Salmagundi Club has supported representational art within a historic venue that features three galleries, a library, restaurant, bar, vintage pool tables, and a preserved period parlor. Women weren't admitted as members until 1973. Prior to 1973, the works of female artists were displayed and celebrated, but membership was regulated to the nearby Pen and Brush Club. Along with the long tradition of its art salons, the club has acquired over 1,500 works during its years in operation, with many on display, including a vast and fascinating collection of artists' palettes.

The public can catch a glimpse of the history of artists' life in New York when the club opens its doors to the public for many talks and exhibitions.

Salmagundi Art Club, 47 Fifth Avenue

WILLEM DE KOONING
Studio
85 FOURTH AVENUE
EAST VILLAGE

In 1946, things weren't great for Willem de Kooning. Sure, he was known in the art world, but he still fell into a deep depression. His marriage to Elaine de Kooning was increasingly on the rocks—they both drank heavily and openly had affairs (sometimes Elaine would choose her lovers to further Willem's career), which in combination lead to incessant conflict. Feeling trapped in their tiny two-bedroom apartment, de Kooning decided in the stifling late summer to get a new studio to work in. At the time, the artist was in the habit of showing up around town in tattered clothes, and thus his Fourth Avenue studio matched his persona to a tee.

Barren and raw, the place was lit with naked bulbs and had no heat, hot water, or even a bathroom. Yet, because of his rocky marriage, de Kooning would stay in the stripped-down room for days on end, sleeping on a single cot next to his easel. His one studio chair became his everything—a place to sit, read, contemplate his paintings, and set his morning coffee and ashtray. Despite his shabby way of living, it was here that de Kooning made his best work, the paintings that created a kinship between himself, Franz Kline, Robert Motherwell, Mark Rothko, and the like.

Elaine and Willem went their separate ways in 1957, but the couple decided to get back together almost twenty years later in 1976.

Willem de Kooning's Spartan Studio, 85 Fourth Avenue

CHAPTER SIX

ARCHITECTURAL INTERVENTIONS

A marriage of art and architecture
is a fine one. These architectural
gems are more than meets the eye,
with sculptural installations jutting
out of and hanging from buildings,
sometimes using a structure's facade
as a veritable frame. Together, art-
adorned architecture is a celebrated
tradition we want to see more of.

FORREST MYERS
The Wall

599 BROADWAY
SOHO

The blue square and green steel bars on the side of 599 Broadway are two important things at once: a massive public artwork *and* a case of art winning over advertising. *The Wall* by Forrest Myers was commissioned in 1973 for $2,000 by City Walls to cover architectural scars on the twelve-story building's north-facing facade. The piece soon got the nickname "Gateway to Soho," serving as the imaginary entrance into the area where many artists occupied industrial lofts, long before the neighborhood became the commercial shopping hub it is today. Since 1997, the work has caused a lot of controversy between the owners and the state. The owners claimed the piece was causing leaks in the building, but many thought this was a ploy to use the massive—and heavily trafficked—space for giant billboards to generate ad revenue.

The piece was taken down during building repairs in 2002 but remained in storage even after the construction was over. Since the building is in a district that confers landmark status to everything within its boundaries, the sculpture became the subject of a federal lawsuit that Myers filed in 1997, which he lost in 2005. After a temporary removal, subsequent lawsuits, and incredible community support, a compromise was finally made in 2007. The piece was moved up eighteen feet, allowing advertising space to be installed near the ground level. Some of the original aluminum bars were damaged, so new ones were made under the supervision of the artist, who, then sixty-five, was overjoyed. He coyly said if a film was made about the piece, he hoped Brad Pitt would play him.

The owners estimate that without the piece, the wall could generate upward of $600,000 a year in ad space in 2007 dollars . . .

Forrest Myers, *The Wall*, 1973, 599 Broadway at Houston

GUTZON BORGLUM
The Four Periods of Publicity
20 VESEY STREET
LOWER MANHATTAN

His name may not be a household one, but every-one knows Danish-American sculptor Gutzon Borglum's most famous work—the epic Mount Rushmore in South Dakota. Although the scale is quite miniscule compared to four giant presi-dential heads, Borglum's deft touch has also been left on New York City. Four of his sculptures, made with his wife Estelle Rumbold Kohn, decorate the facade of the former Evening Post Building in the Financial District.

Representing the Spoken Word, the Written Word, the News-paper, and the Printing Press, *The Four Periods of Publicity* peeks out over the ninth floor of the ornate New York Evening Post Building, designed in a rare architectural combination of Art Nouveau and Vienna Secession styles. The building was designated a New York landmark in 1965, as were Borglum's beautiful sculptures.

Borglum was a traditionalist who found modern art to be an insult to his craft. He ruffled feathers in New York with his vocal crit-icism of the 1913 Armory Show, famously calling Marcel Duchamp's now-beloved *Nude Descending a Staircase* the *RUDE Descending a Stair-case*. Needless to say, Duchamp was unfazed by his comments and went on to bring Cubism to the forefront of the art world.

Gutzon Borglum, *The Four Periods of Publicity*, 1906, 20 Vesey Street

HILDRETH MEIÈRE
Dance, Drama & Song

RADIO CITY MUSIC HALL
50th STREET FAÇADE
MIDTOWN WEST

The extravagance of the Art Deco era is epitomized in the New York City skyline, where the exquisite feats of architects and artisans are forever on display. One architectural beacon of the movement is Radio City Music Hall, built in 1932 by architects Edward Durell Stone and Donald Deskey. The building itself is resplendent with details from top to bottom; the fixtures, medallions, decor, and murals all echo the Deco movement that shaped the glamour of Manhattan in the 1930s.

Native New Yorker Hildreth Meière studied art extensively, including Renaissance painting and mural-making in Florence. After school, she found the male-dominated art world hard to break into, so she took a job working as a costume designer in theaters, a job considered "appropriate" for female artists. Yet her artistic thirst could not be forgotten, and by 1928, she had turned herself into a reputable muralist and mosaicist, nabbing an award from the Architectural League of New York—six years before they admitted female members to boot! Her architecturally integrated public murals, mosaics, and adornments helped to bolster the Art Deco movement in New York.

Meière's expertise in Art Deco design was commissioned for Radio City Music Hall's 50th Street facade. She designed three massive medallion roundels with strong and stoic muses performing dance, drama, and song, each in vibrant colored metal and enamel cast by Oscar B. Bach. Despite their massive eighteen-foot diameters, the medallions are easy to miss in the tourist-centric area.

Hildreth Meière, *Dance, Drama and Song*, 1932, Radio City Music Hall 50th Street facade

iSAMU NoGUCHi
New∫

50 RoCKEFELLER CENTER
MiDTOWN

It's surprising to some to find out that Isamu Noguchi, known more for his simplistic sculptural style, was the artist behind the massive Art Deco steel piece that rises above the entrance to 50 Rock. Weighing in at a whopping nine tons, the work was the winner of an open-call contest in 1938 by the building's former tenant, the Associated Press, which asked artists to propose a cast bronze piece related to the news.

Noguchi, already known as an abstract artist and architect, won the bid with his bas-relief of five reporters urgently seeking out a scoop. The reporters work together with phone, notepad, and typewriter, leaning in toward lines that represent the news-wire's deep network. It was Noguchi's idea to cast the figures in stainless steel instead of bronze, making the reporters silver, sleek, and strong.

The Art Deco piece has a Cubist feel and bears influence from Noguchi's former mentor, Constantin Brancusi. *News* is one of many of the Art Deco-era commissioned art pieces at the Rockefeller Center complex.

Isamu Noguchi, *News*, 1940, 50 Rockefeller Plaza

KRISTIN JONES
& ANDREW GINZEL
Metronome

1 UNION SQUARE SOUTH
UNION SQUARE

"What the heck is that thing?" says everyone passing *Metronome*, ever. The giant wall piece that looms over the south side of Union Square is a mystery to many, with its swirled golden center, nonsensical-seeming counting numbers, and, of course, the now-ceased occasional emission of steam. Aside from being a head-scratching enigma, it's also one of the largest private commissions for public art in history. With the Public Art Fund as a consultant, the developer Stephen M. Ross went through over two hundred submissions before he chose the perplexing *Metronome*, dreamt up by Kristin Jones and Andrew Ginzel. Installed in 1999, the three-million-dollar piece is meant to symbolize the intangibility of time, a force that many New Yorkers are confronted with dozens of times in a New York minute.

The central component, measuring one hundred feet high and sixty feet wide, has an undulating brick wall with a dark circular void, surrounded by gold leaf overlay that dissipates across the panel into gold fragments. Below, a massive rock juts out through the brick wall, and to the left on the glass facade is a digital timepiece that counts the twenty-four hours of the day while simultaneously subtracting the time remaining in the day—so the seemingly nonsensical really does have logical merit after all. To the right is the lunar timepiece, composed of a sphere set into a socket, which is synchronized to revolve with the phases of the moon. And then there is the steam, which used to puff out over 14th Street several times a day, but hasn't worked in several years.

The complicated piece is an homage to the vibrant energy that is New York City.

Kristin Jones and Andrew Ginzel, *Metronome*, 1996–99, One Union Square South

SEAMAN-DRAKE ARCH
Arc de Triomphe
BROADWAY between 215th & 216th
INWOOD

The tiny island of Manhattan is jam-packed from

Battery Park to Fort Tryon, but in 1855 the northern neighborhood of Inwood was home to rolling meadows and bucolic country estates. A regal remnant of these pastoral origins still lingers, buried within the high-rise apartment buildings, fast-food joints, and mom-and-pop shops. Nearly unrecognizable in this setting, you'll find a surprising replica of the Arc de Triomphe, once the grand entryway to a lavish estate, rising above a garage.

In the 1850s the wealthy Seaman-Drake family had a country house built in Inwood as a retreat from their home in Lower Manhattan. The marble mansion sat on a hill overlooking twenty-five acres of Italian-style gardens, scenic walks, ponds, and a private forest that wound down to the marble arch at the bottom. John Ferris Seaman and his wife Anne Drake preferred "Seaman Castle" over their city abode and lived there until their deaths (John in 1872 and Anne in 1878). After 145 relatives contested their wills, the mansion was awarded to Anne's nephew, who turned their lush living quarters into the Suburban Riding and Driving Club. The mansion was converted to a country club with elegant meeting rooms, a café, private dining, and a banquet hall.

Thomas Dwyer bought the estate in 1905 and used it as headquarters for his Marble Arch Company before selling it in 1938. The mansion was then torn down to make way for the Park Terrace apartments, which remain today. Oddly, the arch was not part of the deal, and so it remains, sandwiched between the apartments and small businesses, an eerie and hidden reminder of a Manhattan that once was.

Seaman-Drake Arch, Broadway between 215th and 216th Streets

CHAPTER SEVEN

WHAT ONCE WAS

That seminal gallery, influential installation, or art-filled locale may no longer be with us, but its creative energy lingers in the spot it enlivened— or so we'd like to think.

A wheat field once grew in the shadow of the World Trade Towers. An artist-run restaurant fed dozens of starving creatives while establishing a community in bohemian Soho. A burgeoning art school thrived high above a major commuter center. We remember these pieces as a memorial to more creative and less commercial times.

AGNES DENES
Wheatfield – A Confrontation
BATTERY PARK CITY
LOWER MANHATTAN

Long before it became a sprawling metropolis,

Manhattan was farmland—and an untouched oasis for native peoples before that, but that's a different book....Before the fancy high-rises, financial headquarters, tourist centers, and souvenir peddlers made their way to Battery Park City, the area behind the World Trade Center was a giant, gross landfill. In 1982, artist Agnes Denes decided to return that landfill back to its roots, albeit temporarily.

Denes was commissioned by the Public Art Fund to create one of the most significant and fantastical pieces of public work Manhattan has ever seen. Her concept was not a traditional sculpture, but a living installation that changed the way the public looked at art.

In the name of art, Denes put a beautiful golden wheat field right in the shadow of the gleaming Twin Towers. For *Wheatfield—A Confrontation*, Denes and volunteers removed trash from four acres of land, then planted amber waves of grain atop the area. After months of farming and irrigation, the wheat field was thriving and ready. The artist and her volunteers harvested thousands of pounds of wheat to give to food banks in the city, nourishing both the minds and bodies of New Yorkers.

Agnes Denes, *Wheatfield—A Confrontation*, 1982, Battery Park City

DANCETERIA
30 WEST 21st STREET
CHELSEA

Danceteria: the legendary club of New Wave music, pioneer of video art, and employer of the stars! Imagine, LL Cool J taking you up to the club in the elevator, Keith Haring checking your hat, performance artist Karen Finley and singer Sade serving drinks at the bar, and the Beastie Boys busing tables, while Madonna lights up the stage! Sounds like a movie, right?

Aside from multiple dance floors, the club was one of the first to show video art, early music videos, and found footage in a video lounge designed by artists John Sanborn and Kit Fitzgerald. It also hosted important art performances by John Lurie, Laurie Anderson, and Kembra Pfahler before she developed her Voluptuous Horror of Karen Black persona. You can glimpse a snippet of what the club was actually like, although cinematically, in *Desperately Seeking Susan*. Like most 1980s art meccas in New York, the epic space is now luxury condos, of course.

In 2017 the long-defunct club made the news when construction workers found what they thought was a bomb under the building where Danceteria had been. But the "bombshell" was actually a time capsule from the 1980s! In 1983, Danceteria owner John Argento and promoter Rudolph Pieper bought a World War II practice bombshell from a nearby Army Navy store for $200 and hung it in the club. For three weeks, they had club regulars write letters to the future, filling the bombshell with flyers, notes, and other memorabilia, then buried it beneath the sidewalk to be opened in 10,000 years. It was found a bit early, but was still opened to an entirely changed New York just a few decades later.

Danceteria, 30 West 21st Street

THE DOM

19-25 ST. MARKS PLACE
EAST VILLAGE

St. Marks Place has reinvented itself time and time again, from the farm of Peter Stuyvesant to the center of Little Germany to the gathering place of Beat poets, hippies, and bohemians, then anarchists and punks. Today the Asian restaurants, karaoke joints, and tourist shops barely echo the spirit of what the block once was. The transformation of the buildings at 19–25 into a vape shop, a Chipotle—which has since closed—and a deli felt like the final nail in the post-punk St. Marks coffin. What feels like an eternity ago, Andy Warhol hosted the epic Exploding Plastic Inevitable parties, which were all the rage in 1966, at building 19–25. With a dance club and performance area upstairs and a bar and restaurant on the ground floor, The Dom, named for the word "home" in Polish, was the regular venue for house band the Velvet Underground, featuring weekly performer Nico.

The Factory crowd hung here throughout 1966 in the former ballroom upstairs, sublet by Warhol and Paul Morrissey for their parties. After the Warhol crowd moved on, the club reopened in 1967 as a psychedelia-themed nightclub called Electric Circus. That club endured until someone literally dropped a bomb right on the dance floor—rumored to have been set by the Black Panthers. Shortly after, the club fell out of fashion and closed in 1971. The building was divided up and turned into its commercial facade in 2003.

Even before Warhol, the site was a place of excitement and controversy. Once town houses for the rich, 19–25 were bought up in the 1870s by the German music club The Arlon and turned into German dance venue Arlington Hall. In 1914 there was another shoot-out on the dance floor between Italian and Jewish gangsters.

Teddy Roosevelt and William Randolph Hearst also spoke there.

The Dom/Warhol Club, 19–25 St. Marks Place

GEORGE MACIUNAS
Fluxhall & Fluxus Shop
359 CANAL STREET
LOWER MANHATTAN

Manife

flux (flŭks), n. [OF., fr.
flow. See FLUENT; cf.
a A flowing or fluid di
part: es
discharg
dysenter

<u>Purge</u> the world c
"intellectual", profess
culture, PURG
art, imitation
illusionistic art
PURGE THE

Inspired by John Cage's experimental music, Marcel Duchamp's readymades, and general disdain for the bourgeois art world, the Fluxus anti-art movement, largely lead by artist George Maciunas, carved a conceptual niche for itself in the 1960s and '70s. Fluxus appealed to artists who rejected the predictability of modern art, drawing people like George Brecht, Yoko Ono, Joseph Beuys, and Nam June Paik to partake in its performances and practices. A combination of visual art, performance, poetry, experimental music, and film, Fluxus took after the randomness of Dada, and like Dada, had a serious problem with "serious" modern art.

Maciunas found a headquarters for his movement in 1963 in a tiny space on Canal Street he aptly called Fluxhall. It served as a miniature pop-up shop, where it informally sold many of the Fluxus artists' pieces, like a retail space rather than a stuffy traditional gallery. Fluxhall was open regular hours like a store and had satellite mail-order-only locations in Europe that would send out manila envelopes of newsletters and original art pieces by George Brecht, Ay-O, Dimitri Devyatkin, and other artists. The shop also hosted musical performances, which often spilled out onto Canal Street for lack of space.

At Fluxhall, visitors could buy what has now become the Fluxus legacy—Fluxus boxes and Fluxkits. These compartmentalized boxes contained cards and objects designed and assembled by artists, meant for any person from any walk of life to be able to use and enjoy without any prior art knowledge. Fluxhall closed in 1964, but the movement thrived well into the 1970s.

George Maciunas, Fluxhall and Fluxus Shop, 359 Canal Street

GORDON MATTA-CLARK FOOD

PRINCE & WOOSTER SOHO

Gordon Matta-Clark's artistic practice utilized the city as a medium. He employed architecture as sculptural materials, slicing walls and cutting holes into facades of great buildings as if they were blocks of marble. The artist would transform oddly shaped property lots he'd buy at auction into conceptual projects. Even Matta-Clark's approach to eating and dining in the city became a form of his art.

In 1971, inspired by the communal dinner parties the artists of Soho would hold, Matta-Clark, his then girlfriend Caroline Goodden, and artist Tina Girouard opened FOOD, an artist-run restaurant on Prince and Wooster Streets. FOOD was a pioneer in both menu and artistic concept. Their cuisine ideas, which seem the norm today, were way ahead of their time. The menu was seasonal and local, the kitchen was fully open to the restaurant, and the space served regional and ethnic foods. Giant communal bowls of fresh butter and parsley were ever-present on the counters, and artisan bakers from Vermont would come down to make FOOD's bread.

Infusing art with nourishment, the cooking itself was a performance piece. Artists were weekly guest chefs, including Matta-Clark, Donald Judd, and Robert Kushner. One of Matta-Clark's famous meals was called "Bone Dinner," which included dishes like oxtail soup and cuts of bone-in meat. After dinner, the remaining bones were scrubbed and strung together into parting gifts for guests to wear home.

FOOD was a support system for many struggling artists, providing balanced meals for a low price, pocket money for the artists employed, and serving as a community gathering space. Matta-Clark sold FOOD in 1974 to focus on his own artistic endeavors.

Gordon Matta-Clark, FOOD Restaurant Site, Corner of Prince and Wooster

GORDON MATTA-CLARK
Day's End
(THE FORMER) PIER 52
WEST STREET & GANSEVOORT STREET
GREENWICH VILLAGE

The unremarkable parking lot for the Depart-

ment of Sanitation was the site of the lost Thirteenth Avenue and a once-bustling Pier 52. The former piers along the Hudson River were remnants of various industrial eras of New York and had become mostly abandoned by the 1970s. Artists like Gordon Matta-Clark took advantage of these obsolete structures, using them as the basis for art experiments, installations, and as material for artworks themselves.

In 1975, as a monument to Chelsea's long industrial age of the nineteenth century, Matta-Clark went to work on Pier 52, turning the structure into a large-scale sculpture. Slicing channels in the pier's floors and ceiling, Matta-Clark transformed the cavernous warehouse into a cathedral-like piece he called *Day's End*. A sail shape was cut facing the Hudson River, a large rosette was carved out of another wall, and a circular slice through the floor gave the effect of stained-glass windows, casting the high noon sun into the dark waters below and spreading the sun's rays throughout the interior of the pier in shapes that changed throughout the day.

Matta-Clark hoped to have the piece open to visitors twice a week, but the police rained on that parade and arrested him for trespassing and defacing property. This wasn't Matta-Clark's first piece on the Hudson pier—he'd done *Untitled Performance* in 1971 and *Pier In/Out* in 1973. The charges were eventually dropped, but *Day's End*'s official inauguration never came to be, and the structure sat vacant until it was torn down.

Gordon Matta-Clark, *Day's End* Site, 1975, the former Pier 52, West Street and Gansevoort Street

GRACIE MANSION
Gallery
15 ST. MARKS PLACE
EAST VILLAGE

The artistic spirit of the East Village of the 1980s

was one to dream about—the city may have been broke, crime may have been high, but artists thrived with creativity, innovation, *and* cheap Manhattan rent! One seminal art hub of the East Village era was Gracie Mansion Gallery, which haunted several locations around St. Marks Place.

Born Anne Mayhew-Young, the gallery's proprietor renamed herself Gracie Mansion in 1981, after New York City's mayoral residence. Her eponymous gallery took on many forms, from Mansion's bathroom, called the Loo Division, to various private apartments, until settling into a proper space on St. Marks.

Gracie Mansion herself was a total innovator. Dismayed by the Soho gallery scene, she began to curate her own shows with artists Buster Cleveland and Sur Rodney—also her partner. They made a name for themselves with a show inside of a parked limo on Spring and West Broadway, hoping to catch Leo Castelli's eye. Mansion launched exhibitions that would come to define the East Village art scene before the AIDS epidemic brought the era to an end.

Gracie Mansion Gallery had several locations, including 337 East 10th Street and 532 Broadway in 1987.

Gracie Mansion Gallery Site, 15 St. Marks Place

GRAND CENTRAL ART SCHOOL

GRAND CENTRAL TERMINAL
89 EAST 42ⁿᵈ STREET
MIDTOWN EAST

Imagine heading to Grand Central Terminal,

easel and canvas in hand, to be taught painting by a modern master?

When Grand Central Terminal opened in 1913, it served as so much more than a transportation hub for New Yorkers. The sprawling forty-eight-acre Beaux-Arts complex was a beacon of architecture, the largest terminal in the world at its time. It was also a showcase of electricity and functioned as a city center, with amenities like shops, restaurants, food markets, a theater, a tennis club, and a 14,000-square-foot exhibition space called Grand Central Art Galleries, which was opened in 1923 by Walter Leighton Clark, John Singer Sargent, and Edmund Greacen. The grandiose terminal seemed an appropriate location to showcase fine art, with visitors' art appetites first whetted by the massive 275-foot celestial mural by Paul César Helleu—a commuter in 1913 noticed that some of the constellations are backward by the way—that dominates the Main Concourse before heading to the sixth-floor galleries. The organization was a nonprofit meant to further the scope of American art, with artists required to donate one work per year for membership, thus underwriting their own organization.

One year after opening, the galleries established their own art school, the Grand Central School of Art. For twenty years, students would shuffle through the terminal, up to the seventh floor in the east wing to be taught by world-class artists such as founding directors Sargent and Daniel Chester French, as well as known artists like Arshile Gorky, Dean Cornwell, and Ezra Winter. The school prospered, swelling to one of New York's largest art programs during its height, until it closed in 1944 due to a decline in attendance.

Grand Central School of Art, Grand Central Terminal, 89 East 42nd Street

LEO CASTELLI Gallery

4 EAST 77th STREET
UPPER EAST SIDE

The brilliance of a gallerist is often overshadowed

by the stardom of the artists they cultivate. The late Leo Castelli was a game changer. Castelli had an impeccable eye—he was the first to show Warhol's Campbell Soup Cans paintings, Jasper Johns's iconic flags, and a slew of other artists who now hang in museums across the world. Castelli opened his first gallery here on February 10, 1957 (two locations now exist at 18 East 77th and 24 West 40th Streets). A year later was Jasper Johns's first show, which established the gallery's role as the catalyst for Pop, Minimal, and Conceptual art. Everybody who is anybody showed here: Robert Rauschenberg, Cy Twombly, Frank Stella, Roy Lichtenstein, Andy Warhol, James Rosenquist, Donald Judd, Dan Flavin, Bruce Nauman, and countless others had their careers launched here.

Castelli set the bar for gallerists everywhere, discovering trends and fostering careers. He nurtured his artists like a patron, giving them monthly stipends to survive on and make more work. His first wife, Ileana Sonnabend, went on to open the seminal Sonnabend Gallery.

After moving to Soho in the '70s, the gallery shifted back to the Upper East Side after Castelli's death in 1999. The gallery is still run by his widow, Barbara Bertozzi Castelli.

Leo Castelli Gallery (original location), 4 East 77th Street

MACDOUGAL MEWS

MACDOUGAL ALLEY
GREENWICH VILLAGE

Tucked off the popular MacDougal Street between West 8th and Waverly Place is an adorable cul-de-sac with a rich artistic heritage.

Originally a row of stables for local homes, built in 1833, the alley attracted young artists in the early 1900s. MacDougal Alley, which is now a quaint block of mews owned by private residents and an art school, really began to thrive when wealthy New York households began using automobiles over the horse and carriage. Artists set up their studios on the private block and with their families inadvertently created a self-contained enclave.

With their large doors thrown wide, the artists of MacDougal Alley had an open studios policy. They could easily advise one another on their work, while their families were close by, creating a self-sufficient community of support.

Over the years, the block held the studios of some of the art world's elite. In 1907, the private enclave went under the public lens, when heiress Gertrude Vanderbilt Whitney moved her sculpture studio into number 19, attracting first the press and then the curious public, who wanted to see why a millionaire would choose to work in a tiny alley. Despite the popularity, artists continued to inhabit the alley, including sculptor Daniel Chester French, who worked here between 1909 and 1912. Isamu Noguchi moved to the now razed number 33 after his release from a Japanese American internment camp, and Jackson Pollock lived here for a year in 1949.

The tranquil mews now fetch upward of $5 million.

MacDougal Mews, MacDougal Alley

PALLADIUM

140 EAST 14th STREET
UNION SQUARE

The heady days of New York nightlife were a time when music, culture, and art intersected in an experience unlike the pay-to-play bottle service scenes of today.

The Palladium—now the Palladium Athletic Hall at New York University—was once New York's most famous nightclub. The original hall, built in 1927 by Thomas W. Lamb, enjoyed a long life as a music venue and movie theater before it became the epicenter of the nightlife universe. In 1985, Studio 54's Steve Rubell and Ian Schrager transformed the theater into a multiroom club with a glow-in-the-dark basement and art-filled VIP room, The Michael Todd Room, that showed off two large canvases by Jean-Michel Basquiat.

Keith Haring painted a massive mural in 1985 for the club's opening, which towered over a neon-lit dance floor, and other murals by Basquiat, Francesco Clemente, and Kenny Scharf were soon added to the wildly popular club. The Palladium was first a spot for New Wave then later techno and house music in the 1990s before it was torn down by NYU. None of the murals were preserved.

Palladium, with works by Keith Haring, Jean-Michel Basquiat, Francesco Clemente, and Kenny Scharf, 140 East 14th Street

RICHARD SERRA
Tilted Arc

26 FEDERAL PLAZA
LOWER MANHATTAN

If you think your commute to work is annoying,

imagine working in the Javits Federal Building in 1981. Back then, a 120-foot-long Cor-Ten steel sculpture bisected the plaza, forcing employees to walk completely around it in order to get to their offices. Artist Richard Serra had been commissioned by the United States Art in Architecture program to create this giant piece called *Tilted Arc* . . . and the workers at the federal building *hated* it.

On the intent of the sculpture, Serra said, "The viewer becomes aware of himself and of his movement through the plaza. As he moves, the sculpture changes. Contraction and expansion of the sculpture result from the viewer's movement. Step by step the perception not only of the sculpture but of the entire environment changes."

But federal employees felt a bit differently. Led by the powerful chief judge of the US Court of International Trade Edward D. Re, an organized group of employees argued in court the piece was an eyesore, too expensive, and attracted rats (steel attracts rodents?). But mostly they felt that it was an inconvenience to have to walk around the giant wall in order to get to their jobs.

After nine years of litigation and appeals, which included testimonies from art world stars, petitions, and even a threat from Serra himself saying he would forever leave the country should his work be altered, the piece was removed in 1989 and destroyed— as per Serra's wishes, as he refused to have the site-specific piece relocated.

Serra never moved away.

Richard Serra, *Tilted Arc* (1981) Site, 26 Federal Plaza

FRANCIS HINES
Washington Square Arch Installation
WASHINGTON SQUARE PARK
GREENWICH VILLAGE

In 1889, to mark the centennial of George Washington's presidency, the city of New York constructed a wood and plaster arch at the north end of Washington Square Park at the foot of Fifth Avenue. It was so popular that in 1890 Stanford White was commissioned to create a permanent marble arch. During the two years of construction, human remains, a coffin, and a gravestone from 1803 were found ten feet below ground level, as Washington Square Park had been a graveyard from the 1700s until 1825. In fact, the remains of over 20,000 people are still buried there today!

In 1980, the arch itself became a temporary site-specific installation. During this time, the park was in desperate need of restoration; graffiti and garbage had overtaken much of the area. The lower portion of the arch itself had not remained immune to the spray cans. As a reaction, artist Francis Hines was picked to install both a literal and figurative bandage for a "wounded monument." Hines and his team of helpers spent days wrapping the structure in 8,000 yards of polyester net, with fabric strips that crisscrossed inside the inner arch. The installation temporarily covered the graffiti, allowing visitors to imagine the structure as a gleaming monument once again.

Like his contemporaries Christo and Jean-Claude, Hines used rope and fabrics to wrap large objects, the tension created representing the "human struggle to free itself from restricting forces." Before the arch, Hines was known around the East Village for wrapping an entire tenement building as well as several police cars—which he was somehow given permission to do.

The beautifully swathed arch was on display for only six days, but its presence inspired the city to begin restoration of Washington Square Park, which has remained a popular open space ever since.

Francis Hines, Washington Square Arch Installation, 1980, Greenwich Village

ITINERARIES

You've made it through the book! Now that you've discovered some of New York's best arty secrets, it is time to treat yourself to an eyeful. Take an afternoon or a long lunch with one of these curated itineraries to rediscover the city. Each route is totally walkable and encircles some of New York's finest restaurants and bars—perfect for having a drink or bite to eat to discuss all that you've seen along the way!

EXPLORING SOHO

Artists first turned their eyes to Soho in the 1970s, enticed by the floor-through lofts and large windows of the former industrial buildings. Officially welcome yourself to Soho by passing by Forrest Myers's *Wall*, lovingly nicknamed the Gateway to Soho, then zigzag your way through the streets. Head down Greene Street and keep your head down to see Francoise Schein's *Subway Map Floating on a New York Sidewalk* embedded in the ground in front of 110. Make an appointment with the Judd Foundation at 101 Spring for an artist-led tour to see how Donald Judd lived and to take in his collection of art and rotating exhibitions. Now, head up to Wooster Street and stop by the corner where Gordon Matta-Clark's FOOD Restaurant (at the corner of Prince) fed Soho's bohemians before walking to number 141 (closed in summer months). Head upstairs to see the Dia Foundation's fantastic preservation of Walter De Maria's *Earth Room*. Finish your walk by heading over to 393 West Broadway to experience De Maria's other piece, *Broken Kilometer*.

OLD OLD NEW YORK
IN LOWER MANHATTAN

Lower Manhattan is a mesh of Revolutionary-era history, Minimalist public sculptures, and of course, thousands upon thousands of tourists. But braving the crowds is definitely worth it to take a spin through history. Lower Manhattan feels like no other place in the city. There's "Old New York" here—the time of glamour, supper clubs, and evening gowns. But this is Old Old New York, where founding fathers roamed, worried about the British, and planned

exit strategies through Governors Island. The artistic highlights may not reach as far back as the eighteenth century, but juxtaposed against the deeply historical architecture from that time, the contrast makes for an awesome way to spend an afternoon.

There's a lot of ground to cover, so we've chosen a few highlights. First, head to the Financial District to immerse yourself in sculpture. Have a seat in the center of Louise Nevelson Plaza (73 Maiden Lane) to enjoy the monochromatic sculptures by that glamorous artist, then head nearby to One Chase Manhattan Plaza to marvel at Jean Dubuffet's playful *Group of Four Trees* sculpture (it's bigger than you'd think!). Take a somber turn to honor those who lost their lives in the 9/11 attacks with the sculptures that became monuments after surviving the attacks themselves. First visit J. Seward Johnson's *Double Check*, which now sits at the northwest corner of Liberty Street and Broadway. Pass by Mark di Suvero's *Joie de Vivre* in Zuccotti Park and head over to Liberty Park just south of the 9/11 Memorial South Pool and look up at Fritz Koenig's *Sphere*, which sits in the elevated park at 155 Cedar Street.

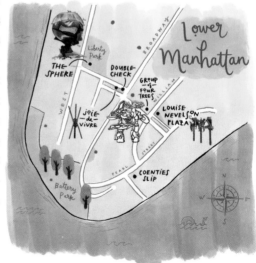

Finally, head over to Coenties Slip and try to imagine James Rosenquist and others painting in an old sail factory that was considered the first artist loft colony. End your day, give yourself a break, and have a drink or snack in one of the restaurants along the picturesque Stone Street—just a stone's throw away.

HOW TO LOITER IN LOBBIES

The time has come to hone your acting skills in the name of fine art. Head to Midtown for a few hours of appreciating the under-appreciated masterpieces in corporate lobbies. Don't be nervous, we'll ease into it for the first stop, at the Solow Collection at 9 West 57th Street. Since this is a lobby that is never open, you can practice your technique for the day while loitering outside of the building. Take extra time to peer in all of the windows to fully take in Sheldon Solow's private collection, which includes Jean-Michel Basquiat, Henri Matisse, Vincent van Gogh, and many more. Easy peasy. If you're still nervous, you can always stop by the King Cole Bar at the St. Regis (2 East 55th Street) to calm your nerves with a Bloody Mary under the gorgeous Maxfield Parrish mural. Feeling better? Walk down to the 53rd Street entrance to 666 Fifth Avenue, pass through the revolving door, and take a stroll through the corridor to experience Isamu Noguchi's undulating ceiling. The security here will probably not blink an eye if you wander through, but if you try to take a photo (which is forbidden), you'll blow your cover. Turn west as you exit at 52nd Street, head over to Seventh Avenue, and walk south to number 787 to gaze at Roy Lichtenstein's 75-foot-tall *Mural with Blue Brushstroke*, which can be seen from both the inside and the outside. Now, head to Rockefeller Center to take in two murals meant for the public to enjoy—first the massive Jose Maria Sert piece in 30 Rock (try to imagine Diego Rivera's now destroyed piece in its place), then to the lesser known lobby of 10 Rockefeller Plaza for Dean Cornwell's glorious *History of Transportation*. If you're in the mood to walk, head back west and then south to 620 Eighth Avenue at 41st Street to spend some time reading the incredible *Moveable*

Type installation in the lobby of the New York Times Building. It is such an interesting and unique way to experience news headlines of the past 100 years. By now, you're an expert in lobby loitering, so it's time to head to the toughest location yet, 505 Fifth Avenue. Here, you must be an invited guest with an appointment, so it's time to fake that phone call and take in James Turrell's *Plain Dress* as you quickly pass in and out of the lobby before you get caught!

ACKNOWLEDGMENTS

A big thank you to Miek Coccia, who served as my friend and sounding board when I decided it was a great idea to write an entire book before presenting it to a potential agent or publisher. The same goes for Maria Krasinski, who I convinced to illustrate and have faith in said book—it has been an honor and an adventure to have such an amazing research partner. I'm thrilled to have had such a dream team, thank you to my agent Lindsay Edgecombe of Levine Greenberg Rostan Literary Agency, and to my editor Shannon Connors Fabricant and designer Amanda Richmond. Thank you to Mr. Giles, who introduced me to Degas, Modigliani, and Seurat as a tiny first grader—little did he know the impact it would have on my life! And to Dr. Morscheck who reignited my thirst for art history as a freshman at Drexel University. I'd also like to thank Stephanie Hague, Rebecca Paul, and Sandra Lang for always being my willing companions on my research jaunts all over Manhattan, to Sailor Hicks for always bringing me a seltzer while I was deep in the writing process, to my parents for listening to me read my drafts over the years, and to Lauren Albrecht for being my partner in Art Nerd New York way back when. Thank you to The Wing Soho and Caffe Reggio for supplying endless cups of coffee and inspiration during my frequent writing and rewriting sessions. Lastly, and most importantly, thank you to Logan Hicks for being my endless source of support, encouragement, and love.
In loving memory of Gilbert Zimmer.

—Lori Zimmer

A lot of stars aligned to bring me to this page.
Brightest among them, thank you to my friend and collaborator
Lori Zimmer for trusting me to illustrate your vision. To our agent
Lindsay Edgecombe for her sage advice and guidance. To our edi-
tor Shannon Connors Fabricant and designer Amanda Richmond
for "getting" us. To my expanding constellation of family from Buf-
falo to Seattle to Tbilisi for your boundless support and encourage-
ment. To my friends Celeste Peterson, Kelli Wilbert, Kaye Oberhau-
sen, Chris Apap, Chris Cobb, Anja Šerc, and Tadej Muršic for your
reassuring messages, calls, and dog memes when 100+ illustrations
seemed insurmountable. To the artists, art teachers, docents, and
explorers who captivated and inspired this doodling shy kid to find
her way of looking at the world. And to my favorite weirdo, Lenny
Jackson. I miss you every day.

—Maria Krasinski

SELECTED BIBLIOGRAPHY
AND SUGGESTED READING

Battista, Kathy. *Art New York: A Guide to Contemporary Art Spaces*. London: Ellipsis London PR Ltd, 2000.

Bone, James. *The Curse of Beauty: The Scandalous & Tragic Life of Audrey Munson, America's First Supermodel*. New York: Regan Arts, 2016.

Brun-Lambert, David. *Pop City Guide: New York*. Paris: Éditions du Chêne, 2017.

Brunner, Jeryl. *My City, My New York: Famous New Yorkers Share Their Favorite Places*. Guilford, Connecticut: Globe Pequot Press, 2011.

Calhoun, Ada. *St. Marks is Dead: The Many Lives of America's Hippest Street*. New York: W.W. Norton & Company, 2016.

Dali, Salvador. *The Secret Life of Salvador Dali*. United States: Dover Publications, Reprint edition, 1993.

Elikann, Jo-Anne. *111 Places in New York That You Must Not Miss*. Germany: Emons, 2015.

Fiore, Jessamyn. *112 Greene Street*. New York: David Zwirner Books, 2012.

Gabriel, Mary. *Ninth Street Women: Lee Krasner, Elaine de Kooning, Grace Hartigan, Joan Mitchell, and Helen Frankenthaler: Five Painters and the Movement That Changed Modern Art*. New York: Little, Brown and Company, 2017.

Gates, Moses. *Hidden Cities: A Memoir of Urban Exploration*. New York: Jeremy P. Tarcher/Penguin, 2013.

Harrison, Marina, and Lucy D. Rosenfeld. *Art Walks in New York*, Third Edition. New York: New York University Press, 2004.

Jackson, Kenneth, and David S. Dunbar, editors. *Empire City: New York Through the Centuries*. New York: Columbia University Press, 2005.

Jones, Will. *How to Read New York*. New York: Rizzoli, 2012.

Kiedrowski, Thomas. *Andy Warhol's New York City*. New York:

The Little Book Room, 2011.

Miller, Tom. *Seeking New York: The Stories Behind the Historic Architecture of Manhattan.* New York: Rizzoli, 2015.

Moss, Jeremiah. *Vanishing New York: How a Great City Lost Its Soul.* New York: Dey Street Books, 2018.

Smith, Patti. *Just Kids.* New York: Ecco/Harper Collins, 2010.

Walsh, Kevin. *Forgotten New York: Views of a Lost Metropolis.* New York: Collins, 2006.

White, Norval, and Elliot Willensky with Fran Leadon. *AIA Guide to New York City,* Fifth Edition. New York: Oxford University Press, 2010.

Wilson, Laurie. *Louise Nevelson: Light and Shadow.* New York: Thames & Hudson, 2016.

Winn, Christopher. *I Never Knew That About New York.* New York: Plume, 2013.

INDEX OF SITES BY CHAPTER AND NEIGHBORHOOD

CHAPTER 1: SURPRISING SPOTS

CHAPTER 4: LOOK TO THE LOBBIES

CHAPTER 5: ARTISTS' HOMES AND HAUNTS

CHAPTER 6:
ARCHITECTURAL INTERVENTIONS

CHAPTER 7: WHAT ONCE WAS

LOWER MANHATTAN

Forrest Myers, *The Wall*, 1973, 599 Broadway at Houston, 210

Francoise Schein, *Subway Map Floating on a New York Sidewalk*, 1985, 110 Greene Street, 26

NOHO

Ken Hiratsuka, *River* and *Nike*, 2008, 25 Bond Street, 40

Pablo Picasso/Carl Nesjar, *Bust of Sylvette*, 1968, University Village, 505 LaGuardia Place, 118

Alan Sonfist, *Time Landscape*, 1965, corner of Houston and LaGuardia Place, 12

Leo Villareal, *Hive (Bleecker Street)*, 2012, 6 Train at Bleecker and Lafayette Streets, 42

EAST VILLAGE

Jean-Michel Basquiat, Residence and Studio, 57 Great Jones Street, 184

Willem de Kooning's Spartan Studio, 85 Fourth Avenue, 206

The Dom/Warhol Club, 19–25 St. Marks Place, 228

Gracie Mansion Gallery Site, 15 St. Marks Place, 236

Tony Rosenthal, *Alamo*, 1967, Astor Place, Lafayette at 8th Street, 128

LOWER EAST SIDE

Jasper Johns, Studio, 1967–88, 225 East Houston, 180

UNION SQUARE

Kristin Jones and Andrew Ginzel, *Metronome*, 1996–99, One Union Square South, 218

Palladium, Keith Haring, Jean-Michel Basquiat, Francesco Clemente and Kenny Scharf, 140 East 14th Street, 244

GREENWICH VILLAGE

GRAMERCY PARK

CHELSEA

MIDTOWN EAST

MIDTOWN WEST

TIMES SQUARE

UPPER EAST SIDE

Leo Castelli Gallery (original location), 4 East 77th Street, 240

Andy Warhol's Town House and Cats, 1959, 1342 Lexington Avenue, 152

UPPER WEST SIDE

Fernando Botero, *Adam & Eve*, 1990, Time Warner Center, 10 Columbus
Circle, 24

Marc Chagall, *The Triumph of Music* and *The Sources of Music*, 1966,
Metropolitan Opera House, 132 West 65th Street, 144

Christophe Fratin, *Eagles and Prey*, 1850, placed 1863, Central Park near
West 70th Street and Rumsey Playfield, 88

Keith Haring, *The Life of Christ*, 1990, Cathedral of St. John Divine, 1047
Amsterdam Avenue, 38

Penelope Jencks, *Eleanor Roosevelt Memorial*, 1996, Riverside Park, 72nd and
Riverside Drive, 120

Augustus Lukeman, *Straus Park Monument* (Audrey Munson), 1915,
Broadway at 106th Street, 84

Auguste Rodin, *The Thinker*, 1930, Columbia University, 1150 Amsterdam
Avenue, 82

HARLEM

Robert Graham, *Duke Ellington Memorial*, 1997, Fifth Avenue at
110th Street, 122

Keith Haring, *Crack is Wack*, 1986, East 128th Street at Second Avenue, 32

INWOOD

Seaman-Drake Arch, Broadway between 215th and 216th Streets, 220

INDEX

Page numbers in *italics* indicate illustrations

MARIA & LORI
KRASINSKI ZIMMER

ABOUT THE AUTHOR
AND ILLUSTRATOR

LORI ZIMMER is a New York-based curator, writer, and author of *The Art of Cardboard: Big Ideas for Creativity, Collaboration, Storytelling, and Reuse* (2015) and *The Art of Spray Paint: Inspirations and Techniques from Masters of Aerosol* (2017) by Rockport Publishers. She founded the popular art history blog Art Nerd New York in 2012, which focused on art history and contemporary art in New York City.

"Liberated" (aka fired) from her Chelsea gallery job in 2009, Zimmer has spent the last ten years crafting her own career in the art world which has included curating, art writing and criticism (both print and online), event planning, PR, artist management, and an array of related gigs that being her own boss has given her the freedom to do. Since 2016, she has worked as an artist liaison on copyright infringement cases for law firm Kushnirsky Gerber PLLC in New York. Zimmer has curated over forty exhibitions and projects in New York, Miami, Nantucket, Philadelphia, Chicago, Hamburg, Germany, Paris, France and the White House under the Obama administration. In 2018 she donated her left kidney to a friend and with new perspective decided to hang up her curatorial hat to focus on writing projects full-time.

Zimmer lives in New York City with her boyfriend Logan Hicks and his son Sailor, but can often be found eating cheese and baguette in Paris with Maria.

MARIA KRASINSKI is an illustrator, designer, and researcher whose work spans cultural diplomacy, arts education, museums,

and humanitarian projects. Born in Buffalo, New York, she's worked and wandered across all seven continents, collecting visual inspiration from vintage maps, hand-lettered signs, and color palettes in overlooked corners. Since her big break illustrating the cover of the Herbert Hoover Middle School calendar, Maria has contributed creative work to outlets such as the Chicago Public Library, Lonely Planet, Muhammad Ali Center, and the *New York Times*.

SHINE BRIGHT,
JONATHAN CASEY
1977-2020

You'll always be our star.

BEUYS

HARING

BOURGEOIS

HOLZER

RIVERA

SONFIST

NEVELSON

JUDD

HOPPER

CALDER

SERRA

BASQUIAT

JOHNS